A
BOOK
ABOUT
GRASS

A BOOK ABOUT GRASS

Its Beauty and Uses

Mary Hunt Kahlenberg
&
Mark Schwartz

Photographs by Mark Schwartz

editorial consultant
Rochelle Reed

E. P. DUTTON · NEW YORK

Published in the United States by
E.P. Dutton, Inc., 2 Park Avenue,
New York, N.Y. 10016

Library of Congress Catalog Card Number: 78-75287

ISBN: 0-525-06983-6 (cloth) 0-525-47630-X(DP)

Published simultaneously in Canada by
Clarke, Irwin & Company Limited, Toronto and Vancouver

Printed and bound in the United States of America.
Color inserts printed in Hong Kong.

Designed by Nicola Mazzella

10 9 8 7 6 5 4 3 2 1

First Edition

Contents

Acknowledgments

The writing of a book always depends on many people in addition to the authors. There were those, such as Dorothy Laupa, who went to the library to locate information for us; there were those who searched through their files for an appropriate picture; and those who lent us their objects to photograph. In particular, Kazuyoshi Kudo helped us in going through the archives of the Kinki Nippon Tourist Company. Throughout our trip to Japan we were indebted to Louise Cort, who served as our guide and translator. Through her we were able to establish personal connections with the crafts people we visited. Janice McGruder's efficient secretarial work expedited our project. And Marc Treib, who helped design the original exhibition, continued to provide us with photographs and field notes and allowed us generous access to his library. We are grateful to everyone who helped us with this project.

A
BOOK
ABOUT
GRASS

Introduction

A Book About Grass began as a museum exhibition. Originally titled "Grass: A Medium for Art, Architecture, and Crafts," the show opened at the Los Angeles County Museum of Art in 1976, and subsequently traveled to Rice University in Houston, the Museum of Contemporary Crafts in New York, and the Renwick Gallery in Washington, D.C.

Reading this book will be very much like a visit to the "Grass" exhibition. At the entrance of the gallery was a miniature Japanese garden with bamboo trees and grasses, a bamboo fence, and a waterfall with water gently pouring from a bamboo spout. Inside the gallery were over one thousand objects made from grasses, all glowing like gold. The exhibit displayed hats and clothing, basketry and containers, tools, utensils, furnishings, and ceremonial objects from many areas of the world, arranged according to function. The exhibition was intended—as is this book— to reveal the seldom-noted but unique and profound beauty of simple, functional objects made from a material with virtually no intrinsic value. Viewers marveled at delicate lace made from straw, admired simple fans for their shape, baskets for their texture and complexity, and brushes for their utility. Common objects were transformed into works of art within the context of museum cases.

Although it was the intention of the exhibit to limit the display to only those objects made of grass in the strictest botanical sense, this was not always possible. Grass in its dried state looks very much like other fibers. In particular, grass shares many attributes with palm, which closely resembles the grass family. Additionally, the National Palm Society urged us to reconsider palm and so, for these reasons, we have included objects made from palm.

Many prominent cultures have been built on the cultivation of grass, although most of these have now yielded to mechanized farming. But rice growing continues as it has for centuries on the Indonesian island of Bali where lush green paddies, fed by elaborate water systems, fill the valleys and rise up the mountainsides. The Balinese landscape is amazing: a patchwork of paddies in vibrant spring green, dark green, and gold. Perhaps even more spectacular is the richly ornate culture that has developed around rice cultivation. The Balinese create an endless stream of palm decorations for every stage of rice development and also for family and communal celebrations. For this reason we chose Bali as the best place to document a major grass culture.

We timed our visit to Bali to coincide with the major holiday of the year, *Galungan*. During this three-day period villages are transformed overnight into palm palaces. *Pènjor*, giant bamboo poles with elaborate palm streamers, are placed in front of every house and the entire community abandons all other work to prepare for the celebration. Women gather in their family compounds to prepare cut palm decorations, while at the entrance the men of the family work on the *pènjor*. As we walked down the small roads in Bali, we saw all this activity and began cautiously peering into the compounds. Invariably, family members would beckon us in and a youngster, delighted to demonstrate his English, would interpret the bustle around us. None of the decoration makers skipped a beat. They talked with neighboring workers as their skillful hands cut the palm leaves into intricate forms. Others assembled the offerings, adding fresh flowers and brightly colored mounds of glutinous rice. Small offerings would be placed on stands outside the compound gate. A second batch would decorate the family temple within the compound. Later in the day we were treated to a spectacular sight: a parade of Balinese women, dressed in their best sarongs, carrying tall towers of offerings on their heads. They were walking to the nearby temple where their decora-

tions and food would be blessed by priests. Once their prayers had been offered, the women lifted the heavy, decorated towers back on top of their heads and returned home, where the consecrated food would be consumed by their families.

Everywhere one looks in Bali there is grass or palm. Most buildings are bamboo, covered with grass or palm thatch. Farmers use pointed bamboo sticks to carry large loads of cut grass from the fields. Vehicles weave around mounds of rice drying on the roadside. Quite simply, life in Bali revolves around grass—primarily the growing of rice, which has brought prosperity to the island. The Balinese recognize that they have been blessed with a most fertile land and, in their elaborate ceremonies, they repay their gods accordingly.

Japan, the second country we decided to concentrate on, is also a rice-growing area. Additionally, it is renowned for its beautiful traditional uses of bamboo. Unlike Bali, craftwork in Japan is not a matter of participation by the community when the need arises. Crafts there are highly developed skills that are passed down by individuals from generation to generation. An apprentice becomes a master only after decades of practice. In the making of a basket, every step is carefully considered. For instance, the craftsman determines which type of bamboo to use, when to cut it, how to dry it, which tool will best perform each task, and visualizes the overall transformation from the original material into the finished object.

In Japan one does not simply invite oneself into the workshop of a craftsman. A proper introduction is essential. Once it has been obtained, each craftsman is happy to explain what goes into his work. Michihito Matsui was busy preparing rough, green bamboo flower containers for New Year's on the cold, wintry day when we visited him. He sat working in a small, raised room facing the street. Around him were objects accumulated over many years: tools, small boxes holding tea-ceremony utensils, and papers of various sorts. Everything was within his reach, and as he talked to us he would pull out a particularly beautiful utensil signed by a well-known tea master, or perhaps a letter from a foreign visitor. Matsui told us stories by the hour as we huddled around his brazier of hot coals attempting to warm our hands. We toured his large inventory of bamboo,

some of it freshly cut the previous fall and now in the process of drying. One particularly fine group of bamboo was mottled with cooking smoke from having spent two hundred years as beams in a farmhouse kitchen.

We also visited the Japanese basketry artist Azuma, who had not been born into a basketmaking family but had apprenticed for many years. After working in traditional forms for over two decades, Azuma began making sculptural forms with the same basketry techniques, and he is now considered to be one of Japan's premier artisans. We spent many hours photographing Azuma as he worked in his tiny space. He sat amid perfect order. His tools and materials were laid out for the job at hand. He concentrated completely on his art, working one portion of the form, observing the shape, feeling the form with his hands, making adjustments and correcting again and again before proceeding to the next step. When he finished working, we all sat down to a lunch of hot soup with fried *moche*, a special rice cake made for New Year's.

We developed such personal contacts as these in part because there had been so many unidentifiable objects in the original "Grass" exhibition. Grass material usually is not included in books on crafts and folk art. Occasionally, something appears labeled "made of fiber," but precise identification of materials is extremely rare, and such items as kitchen or farm tools are considered too commonplace to be mentioned at all. Museum research did result in some adventures. Wandering through long rows of open steel shelves, I might pick up a basket covered with so much dust that I realized I was probably the first person to handle it since it had been placed there several decades before. And one evening, so zealous had I become in searching through obscure materials, that I was inadvertently locked in for the night! By and large, however, museums yielded little concrete information about grass objects. However, after viewing many collections and handling the materials, bits of information began to accumulate like puzzle pieces. Information about grass—what was made from it, where it came from, how it was used—began to fit together.

Until recently there had been very little interest in basketry and other ceremonial and utilitarian materials made of grass. Things have changed considerably in the last few years, owing

to three recently developed sensibilities: a desire and need for a link with the past, the ever-increasing appreciation of handmade objects, and rising ecological concerns.

The wish to forge a link with the past is not just the expression of an interest in history or in collecting antiques, but an acknowledgment of the desire to understand the ways in which other peoples relate to their world. To see an object that has been made in the same manner for thousands of years is to focus on a culture that has not yet broken its thread with past generations. Such craft and art traditions remain because they continue to satisfy a need, perhaps as a part of a religious tradition that has evolved highly symbolic forms such as the Japanese braided rope, *shimenawa*, which marks personal boundaries. An everyday object, such as a strainer, satisfies the need for utility—the strainer's function determined its essential form long ago, and improvements were unnecessary. From our contemporary point of view this pure functionalism also commands considerable aesthetic qualities.

Today, as the production of fine hand-crafted items becomes more and more rare, there is a strong resurgence of interest in such objects, in the same way when on the last day of a great exhibition people are compelled to catch a final glimpse of them. Indeed, the handmade object is threatened with extinction. Machines stamp out vast quantities of uniform products. Yet to feel another human spirit is embodied in an object remains an immensely satisfying sensation. To hold an object and to know that the craftsman had immense respect for the natural materials used, to recognize the skill used in adapting the materials and his careful contemplation of the final object, is to make contact with another mind, and often with another cultural world.

Perhaps we can give this material a new life through appreciation of its natural beauty, its contours, its tactile qualities, its coloring. But if we cannot, then at least in *A Book About Grass* we have captured other centuries and other worlds for you to enjoy.

Agriculture

GRASS

The plains of North America, the pampas of South America, the steppes of Eurasia, the veldt of Africa—nearly one-quarter of the earth's surface is covered with grass. There are over 500 genera and 4,500 species of grass that are known botanically as the family Gramineae. The world's most abundant plant family is also the world's most economically important vegetation, for grass provides the staple food of mankind and is also a major source of animal fodder. The variety of grasses is astounding. Common grasses include lawn grasses, hay and pasture plants, and all of the cereals—wheat, rice, oats, barley, rye, and corn. Reeds and canes, such as sugarcane, are part of the grass family. The largest grass, and one of the few woody types, is bamboo.

Most grasses look alike and all grasses share the same basic structure: a hollow-jointed stem, nodes at intervals along the stems, and bladelike leaves. Veins run parallel on the leaves of grass plants, a clue to distinguishing them from other plant types, which have branched veins on their leaves. When grasses flower, they send up inflorescences, which are spikelets of tiny flowers or seeds. At maturity, each inflorescence has dry, seedlike fruit, called *caryopsis* or grain, attached to its five or more slender, radiating ribs. The grain, the grass plant's precious product, is protected by a brown husk.

Grasses have tenacious underground root systems that provide an alternative method of reproduction. Most grasses form buds at the base of the plant. These buds develop into shoots, which strike roots into the air and form clumps around the original parent plant. In this way many grasses multiply even if their fruits are destroyed by a storm or are bitten off by a grazing animal.

CEREAL GRAINS

Today, as in antiquity, cereal grains provide most of the world's food. Before recorded history the discovery that seeds of certain wild grasses were edible led to their regular collection and cultivation. Man ended his reliance on erratic, spontaneous cereal growth by attempting to plant seeds and harvest the grain. An Egyptian legend credits Isis, the wife of the god Osiris, with drawing her husband's attention to wild-growing wheat and barley. At the urging of Isis, Osiris then instructed his people to break up the land in the Nile valley after the annual flood had receded, to sow seed, and to reap the harvest. Similar stories are told in other cultures. In Greece Ceres, the goddess of the harvest, introduced the planting of grain and the term *cereal* is derived from her name.

The cultivation of grain, a profound step for early man, transformed hunters and gatherers into settled farmers, leading to changes in all aspects of life. People grouped together to work the land and began to worship gods thought to be responsible for the growth of grain. Successful cultivation brought security and then prosperity to early peoples, which in turn had a dynamic effect on their social, political, artistic, and religious life.

Over the centuries rice has become the most important of all the cereal grains—rice is the basic food of the entire continent of Asia—and as in Egypt and Greece, myths about the early cultivation of rice are found throughout the Orient. The Chinese religious calendar was based on the planting, growing, and harvesting of rice. Dependence on rice crops led to the development of elaborate and colorful rituals to assure its abundance.

One of the most ritually ornate agrarian cultures remaining today is that of the people of Bali. They raise two crops a year, more than sufficient rice for the needs of their population. Extensive terracing, highly developed irrigation, careful seed selection, and natural methods of fertilization are practiced throughout the island of Bali. In addition, the Balinese believe that their success lies in the hands of Déwi Srī, the rice goddess. Like the rice itself, Déwi Srī is an integral part of their lives and she is treated with reverence, for she is an honored guest.

A Balinese rice paddy is cared for constantly, as though it were a member of the family. The Balinese perform endless ceremonies attendant on the growth of the rice. Before a rice paddy is prepared for planting, holy water is poured into the canal that floods the field. As the water flows in, an offering is made to the evil spirits—occasionally this takes the form of a cockfight—to satisfy their thirst for blood. Then the land is plowed and a banquet is held. The Balinese consider this feast a good investment because the gods, pleased by the gay and colorful spectacle, will be obliged to repay the donors with a plentiful harvest.

To begin a new crop a Balinese rice farmer selects seed from the most beautiful stalks of the previous harvest. The seed is soaked for two days, spread on a mat in the sun, and kept moist until it germinates. On a propitious day set by the religious calendar, the seed is planted. In approximately two months the densely growing young seedlings are ready to be transplanted to neighboring paddies. As new shoots appear, the paddies become saturated with a vibrant green. Offerings of flower petals and incense are prepared to protect the seedlings from hungry caterpillars. When the grain appears on the stalk, the plant is thought to be pregnant, and the Balinese leave at the paddies small trays of woven banana leaf filled with the same sour fruits that appeal to a pregnant woman. As the grain ripens, the rice becomes vulnerable to mice and, especially, to birds. Farmers place scarecrows in the fields, fly kites, and install wind-powered noisemakers to scare the pests away. When the birds are no longer tricked by these methods, watchmen stand over the paddies, calling out and beating bamboo drums in order to keep the birds in the air.

When the rice is finally ripe, preparations for a harvest festival begin. Cockfights are staged, followed by a day of stillness when no one may enter the rice paddies. Two days later, offerings are left for Déwi Srī, and then the harvest officially begins. Men, women, and children help with the harvest, cutting the stalks and tying them together in bunches. The finest bundle is made into an image of Déwi Srī, and she is dressed in a skirt of white cloth. A headdress decorated with flowers is made with the ends of the stalks, and a face is fashioned from cut palm leaf. Later, a procession carries the Rice Mother figure to the village temple. There she is blessed by the temple guardian and placed on a throne inside the granary where she can oversee her crop.

BAMBOO

The word *bamboo* derives from the Malay word *bambu* or *bambusa*. The origins of this word are obscure, but one explanation has it that the staccato-sounding word imitates the crackling and exploding sounds made by the large hollow grass when it is burned.[1]

Bamboo is a giant perennial grass with a hard, woody, jointed stem. Like grass in a moist lawn, bamboo grows rapidly—as much as eighteen to thirty inches *a day*—reaching full size within a few months to a year. Some varieties grow as tall as one hundred feet. One unusual characteristic of bamboo is that from the time the bamboo shoot breaks through the soil its diameter remains the same and all the nodes are in place, with the distance between the nodes increasing as the bamboo grows in height. Though at a glance bamboo appears to be a leafy tree, bamboo stems do not put out actual branches, for like all grasses, bamboo is a pointed plant with sheath leaves around the stem. Fine, feathery shoots appear at the tip of the bamboo after the stem has reached its full size and has begun to harden. Eventually, other shoots grow out from the nodes.

Bamboo is strong, lightweight, and grows in abundance in warm and tropical climates. For this reason bamboo serves as the most prominent wood of the Orient. It is ideal for construction work, furniture, utensils, and even as paper and fuel. One sees scaffolding, bridges, and buildings

of bamboo. The strength of this grass is due to its tubular structure and to the large amounts of silica in its composition. Although tough and sturdy, bamboo can be worked with simple tools. A wide strip of bamboo can be trimmed by merely tapping the end with a knife and pushing the knife through the bamboo. Much more energy, time, and skill are necessary to accomplish this same task with a piece of wood. In addition, bamboo possesses considerable flexibility after it is split. After having been heated, bamboo can be bent and will retain its shape permanently, thus lending itself easily to decorative patterns.

Perhaps the most satisfying feature of all is the simple beauty of bamboo. Like most grasses bamboo has a shiny green outer skin, but when the skin is removed, the core has a fine, straight grain of a pale beige or gold color. The nodes act as an aesthetic counterpoint to the smooth surface. When bamboo is made into a refined object, careful attention is paid to the section where a node will appear, for the node is the most distinctive characteristic of bamboo.

PALM

Palm is not a grass. However, the family Palmaceae, comprising more than four thousand different species, is closely related to the family Gramineae. It is not easy to differentiate between grass and palm. Generally, palm strips are longer and more supple than grass. Palms vary in size from ground-hugging dwarfs like the Serenoas of Florida to the giant wax palm of the Andes, which sometimes grows two hundred feet high. Rattan palms in Southeast Asia climb like vines, winding upward for several hundred feet through dense jungle before they reach sunlight.

Palms are highly ornamental plants. Most of them have straight trunks with a crown of fan- or feather-shaped leaves at the top. Powerful forms in the landscape, they also have a multitude of uses. The long leaves of the pandanus palm (Pandanaceae) are plaited for matting, rough thatch, walls, and fences. The coconut palm (*Cocos nucifera*) provides food, drink, shelter, and clothing for many peoples. In some areas of Indonesia entire populations depend on the wild lontar palm (*Borassus sundaica beccario*) for their survival. The inflorescence of the lontar produces a sweet juice, an important source of food. The lontar's full, fan-shaped leaves are used for making everything from thatched roofs to simple umbrellas. When bent and tied, the leaves form a bucket and occasionally function as a sounding board for musical instruments. Individual leaves are plaited into hats, baskets, mats, sandals, and children's toys. At one time the palm fiber was even woven into cloth for clothing.[2] On the Indonesian island of Roti coffins are made of lontar trunks. Palm, more than any other plant there, supplies most of the necessities of life and death.[3]

1. Trees protected for the winter, Botanical Gardens, Kyoto, Japan. Appearing like dancers in a circle, these tree trunks have been covered for the winter with layers of rice straw. The straw provides protection from frost and the warmth of the straw draws bugs out of the trees. In early spring, the coats are removed and burned, bugs and all.

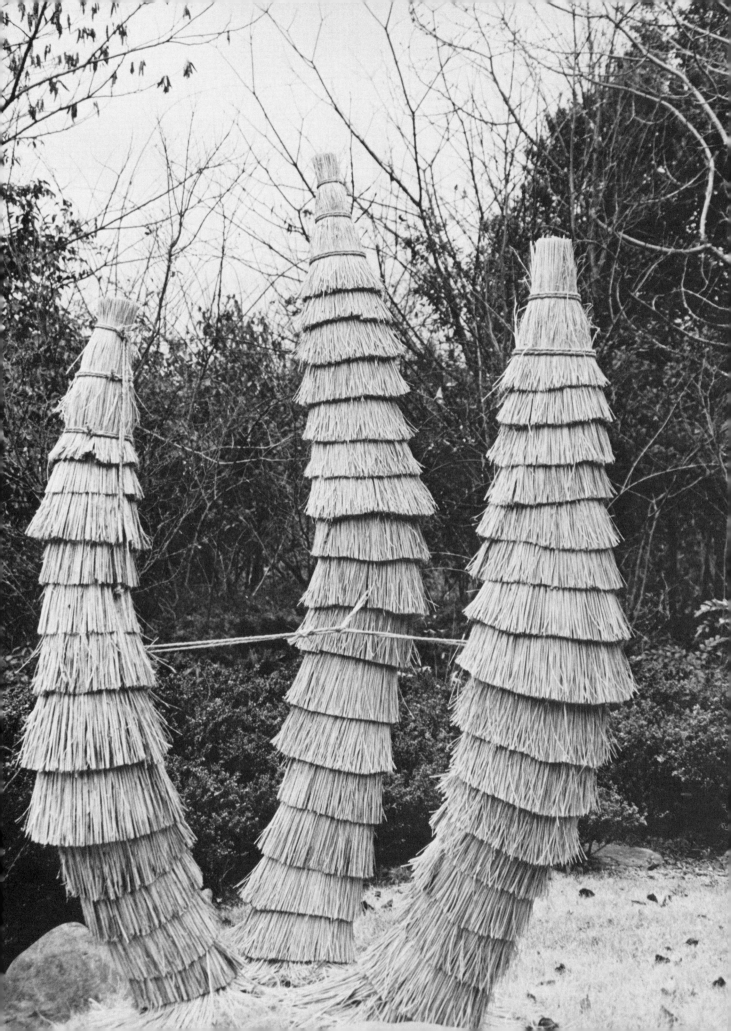

Ceremonial

When the ceremony is over and the bride and groom run to their waiting car, wedding guests shower the happy couple with handfuls of rice. Tossing rice on newlyweds is a traditional wedding rite, one based on ancient survival needs. The custom demonstrates the hope for fertility in both population and cultivation, and this preoccupation with continuity is still a primary concern in religious practices throughout the world.

The need for food is essential, and throughout history man has sought to understand the natural elements that produce it. Primitive man brought order to the apparent chaos of the elements by conjuring up a supernatural world. He created deities to reign over specific aspects of the natural world so that the appearance of sun, rain, wind, and pests would not seem entirely capricious. Keeping the deities attentive and pleased could be accomplished in various ways: the clashing of cymbals, a quiet prayer, a precious gift, a decorative offering.

The people of Bali pay daily respect to their gods, treating them like high-ranking members of society. The gods are perceived as connoisseurs of art; everything is prepared for them with great concern for beauty. Ritualistically, the gods are offered many gifts—food, ingredients of the betel chew, clothing, flowers, and jewelry. In every Balinese household a few grains of rice, some flower petals, and occasionally, incense are placed on banana and palm leaves each morning.

These leaves are set on the street in front of the house or shop as offerings to the gods of the hearth fire, water, and granary. By returning a bit of food, the Balinese feel that they have not stolen food from the gods.

For important ceremonies Balinese women work communally for several days beforehand, making palm leaf decorations, adding flowers, fragrant oils, and cooked rice. The perishability of the offerings and the continuous need for the ritual have kept the art of making palm decorations alive and dynamic.

In Bali and throughout the world fertility deities are thought to be female. Grain cultivators worship the Corn (or Wheat or Rice) Mother. The Balinese Rice Mother, Déwi Śrī, is always symbolized by a female figure, often made from palm leaves. In Europe, Christians have discarded the worship of objects but retain a remembrance of this practice by means of ornamental harvest decorations made into the shape of animals, stars, rings, horseshoes, cornucopias, crosses, and sometimes, the female form. Whatever their shape these decorations are known as corn dollies, even though they are actually made from one of the cereal grains such as wheat, rye, barley, or oats.

The ancient Japanese believed that the spirit of the rice paddy lived in the mountains during the winter, and joyful spring festivals were held to entice the spirit down into the fields containing the young rice seedlings. A similar Greek myth tells how Demeter, the goddess of tillage, descended into the underworld in search of her daughter Persephone. Her return from this journey was celebrated annually as a spring rite.

The harvest ceremony was a most elaborate agricultural rite. It was often based on the belief that the spirit of the grain lived in the last sheaf to be harvested. This sheaf was preserved for the winter by being woven into a straw ornament or female figure (essentially a corn dolly). In ancient Europe the grain-fertility spirit was symbolized by the making of life-size straw figures. In ancient Brittany life-size straw figures were paraded through the streets at the end of the harvest. In Poland and Czechoslovakia these early forms were adapted by Christians and carried in Lenten parades. Even today the Japanese place large straw figures in the fields to ward off evil spirits (see figs. 15 and 16).

Man's dependence on agricultural deities was broken by the technological developments of the late nineteenth and early twentieth centuries. With the discovery of the fundamental principles of plant growth, agricultural yields have increased. Unfortunately, specialization in the production of food, combined with mechanization and the emergence of large-scale corporate farming interests, has removed people from any direct involvement in food growth, to the extent that many people do not even recognize common foodstuffs in their natural state.

After a century of industrialization we are again becoming sensitive to our natural surroundings and the need for spiritual meaning in life. Many of the objects made for ceremonial purposes have remarkable beauty. Because they are made to glorify a supernatural being, their production is guided by a deep inner faith and imbued with grace, beauty, and serenity, qualities admired by the gods but rapidly disappearing from our technological age.

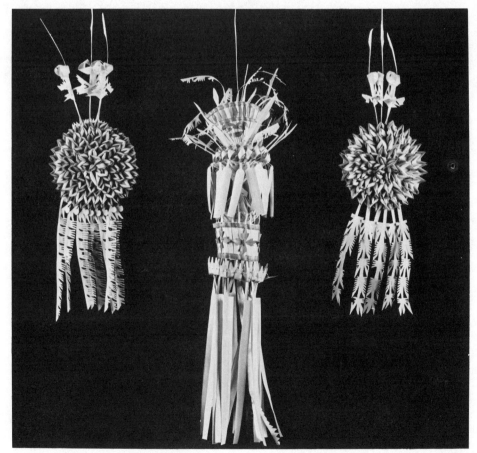

2. *Lamak* (altar hanging), Bali, Indonesia.

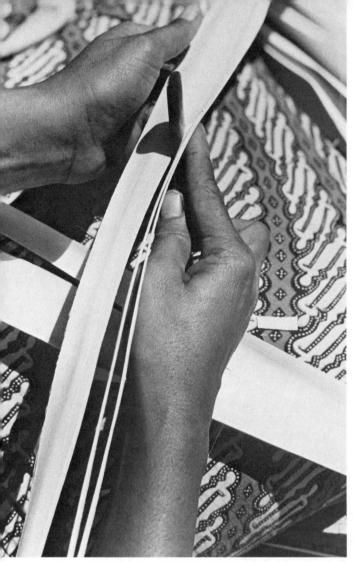 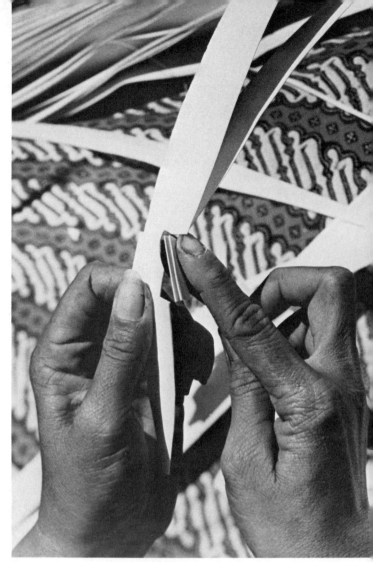

3 3a

Steps in constructing a Balinese *lamak*. For special ceremonial occasions Balinese women work for several days to prepare their family's large decorations of coconut and sugar palm. They are made in sections and joined together. The palm, purchased in the market, is a natural off-white color. For decorative purposes some fronds are dyed bright pink, green, and blue. The women work in a group, cutting sections as they are needed. Their only tool is a sharp knife, which they handle with considerable dexterity.

3. To begin a decoration from a palm frond, the spine is cut off, dividing a leaf in half.

3a. Many leaves are cut to form one part of a decoration. After the first element has been shaped, it becomes a template that is used to guide the cutting of several pieces at one time.

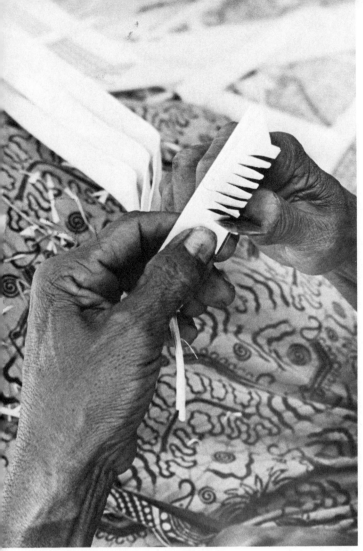

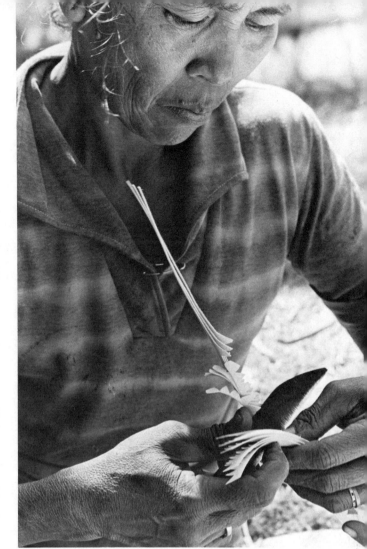

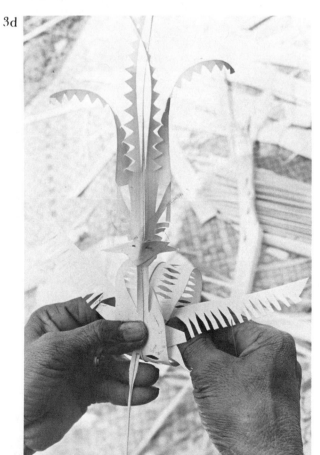

3b 3c

3d

3b. A second component is fashioned with quick, featherlike slicing.

3c. Cut pieces are looped around other cut leaves . . .

3d. . . . and pinned together with a small piece of palm spine.

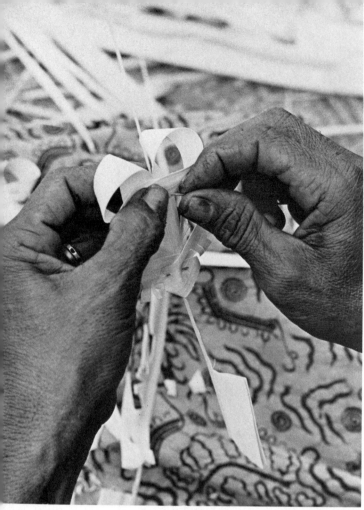

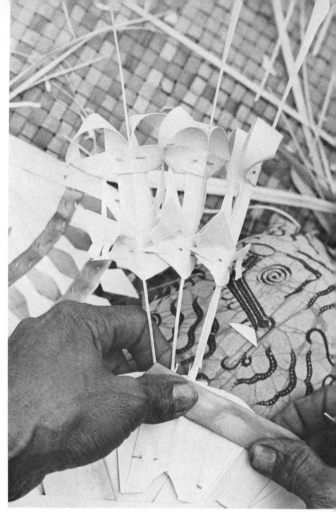

3d

3e

3e. A decorative colored edge is added with small spine pins.

3f. A fan-shaped face is made for the top. Individual pieces of palm are stacked, tied at one end, and cut as a group.

3g. After the pieces are spread into a fan, colored strips are laid over the top and pinned into place. The face is sewed on with needle and thread.

3f

3g

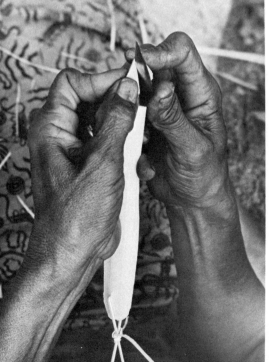

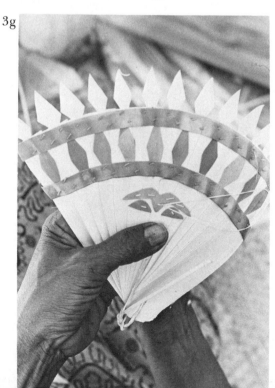

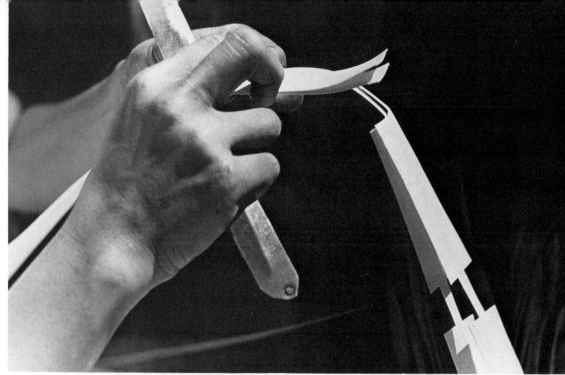

3h. Another part for the top is made of thin hanging strips.

3i. The ends of the strips are pinned, forming a cone shape.

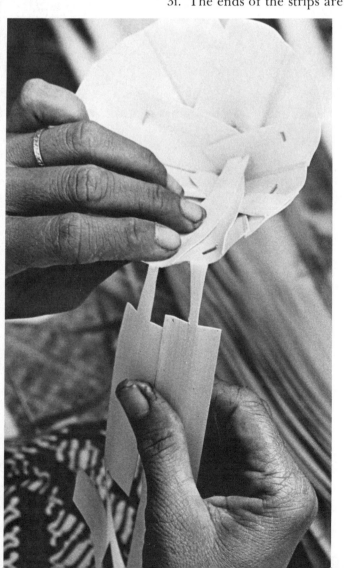

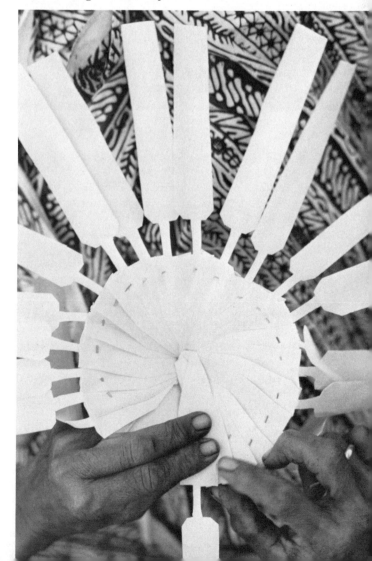

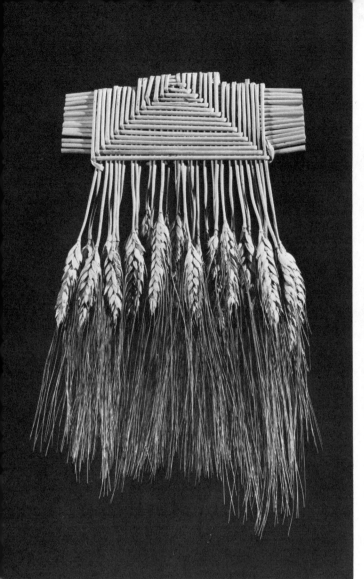
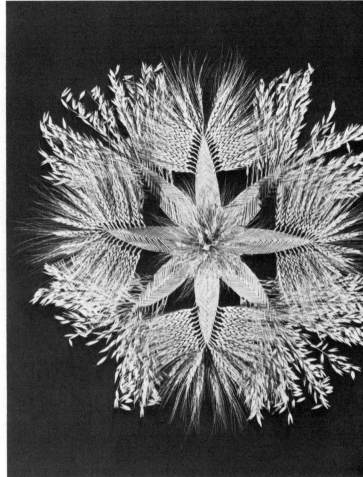

4 5

4. Corn dolly, "Arab Cage," Morocco. 16½" x 12". A cross form is one of the simplest styles of corn dollies, a tradition that continues throughout North Africa today. This corn dolly was purchased off the wall of a small restaurant in the mountains of Morocco. The long, black-bearded wheat is the dominant feature of this piece.

5. Corn dolly, "Workman's Star," Welsh-style, by Doris Johnson, Luray, Kansas. Diam. 27". This corn dolly, made of wheat and oats, combines the evening star (center portion) and the Welsh fan (pointed sprays). This style supposedly originated in Wales and symbolized the appearance of the evening's first star, which signaled the end of a day's work.

6. Christmas tree decoration, Sweden. Diam. 7½". Shaped like the Star of David, this dolly is made of wheat straw with a cluster of oats in the center. Symbolically, it connects the early tradition of the harvest celebration with later Christian motifs. Collection of Mark Schwartz.

7. Christmas decoration, Sweden. 9" x 13". This contemporary Christmas decoration of wheat straw is made in the form of a mobile. Collection of Mark Schwartz.

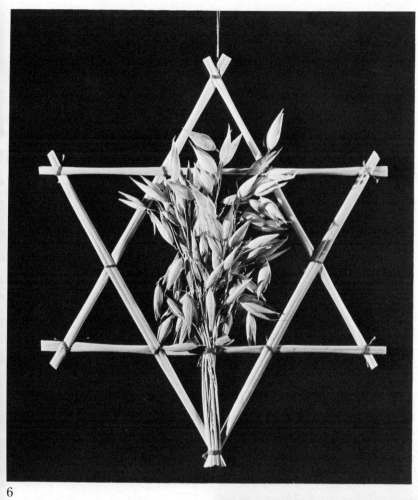

6

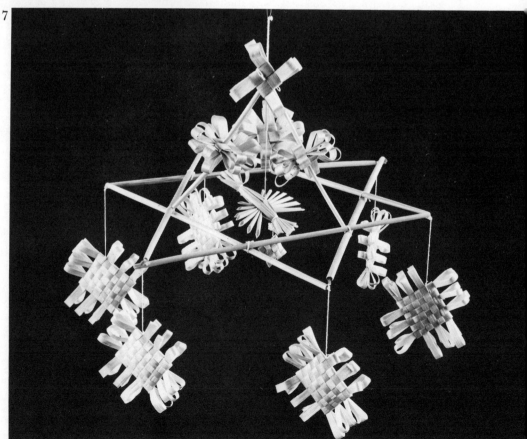

7

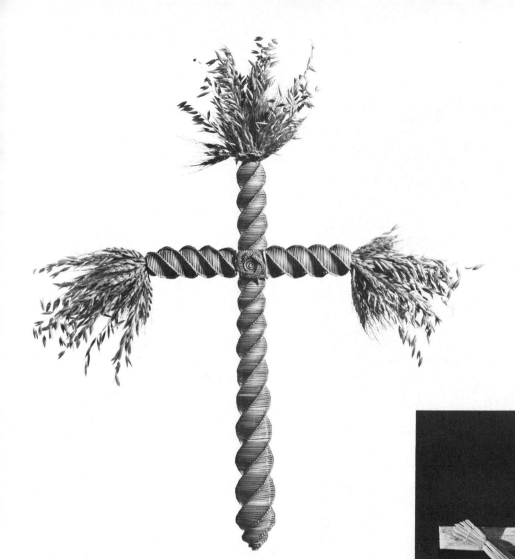

8. Harvest cross, by Doris Johnson, Luray, Kansas. 26″ x 21″. This cross of oats and wheat is made in a spiral, plaited form, the most popular corn-dolly technique used in England. The tradition of making corn dollies has been revived in England recently, and Doris Johnson is one of several Americans who have spent time there learning the craft.

9. Crucifix, Mexico. 47¾″ x 29″ x 10″. This cross of golden straw conveys a simple spiritual message.

10. Straw marquetry cross, San Luis Valley, New Mexico. 16½″ x 10½″. A fondness for bright, shiny surfaces probably led to the use of straw "gilding" on objects made by the peoples living in the barren hills of New Mexico. The gilding technique, carried to the New World by the Spanish, was traditionally used by the Arabs in North Africa. The straw was placed in a mixture of resin, soot, wax, and water boiled together to make a black adhesive. The strength of the adhesive is confirmed by the fact that crosses made this way often remain in good condition for one hundred years. In this cross the black provides a strong contrast to the golden straw. Collection of the Museum of International Folk Art, Santa Fe, New Mexico.

11. Straw Madonna, Mexico. 13″ x 11½″. This straw Madonna derives from Mexico's Baroque period. The luminous quality of the straw is reminiscent of the gold used on Mexican church decorations. Collection of Mark Schwartz.

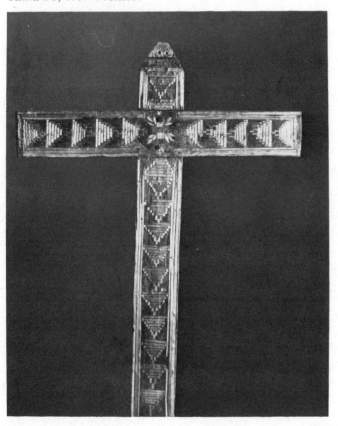

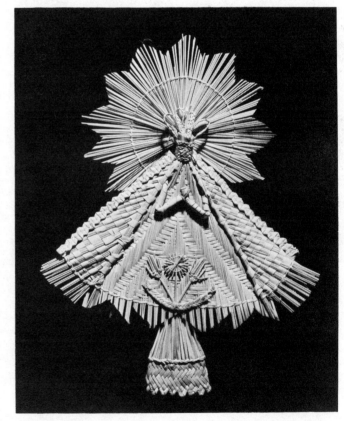

12. Harvest fertility symbol, Japan. 11" x 4". Small, folded papers are placed on top of this harvest fertility symbol, which is a bundle of rice grain bound together and braided at the top.

13. Sun figure, northern Bihar, India. 16¾" x 12". Made of brightly colored sikhi grass, this sun figure was crafted with coil and wrap techniques—the face and pedestal are coiled, the rays are wrapped. Part of a traditional folk art form, the anthropomorphic sun image is gay and lively. Collection of Carolyn West.

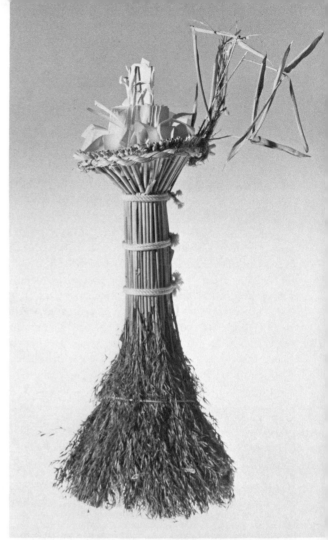

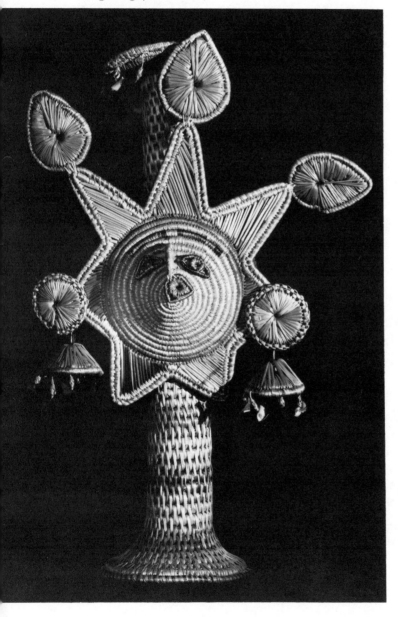

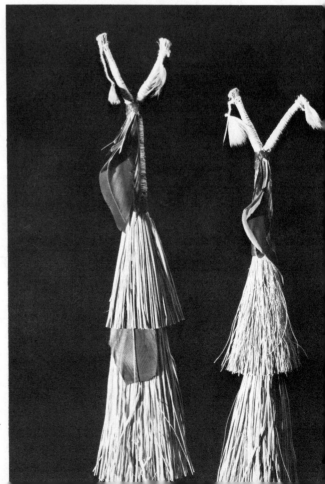

14. Dance effigies, Goiás, Bananal Island, Brazil. 13" x 3". These two figures are miniature versions of costumed dancers. They are made from simple bundles of grass tied around a wooden stick and decorated with bright feathers, and are held by the dancers as they perform. Collection of the Natural History Museum of Los Angeles County.

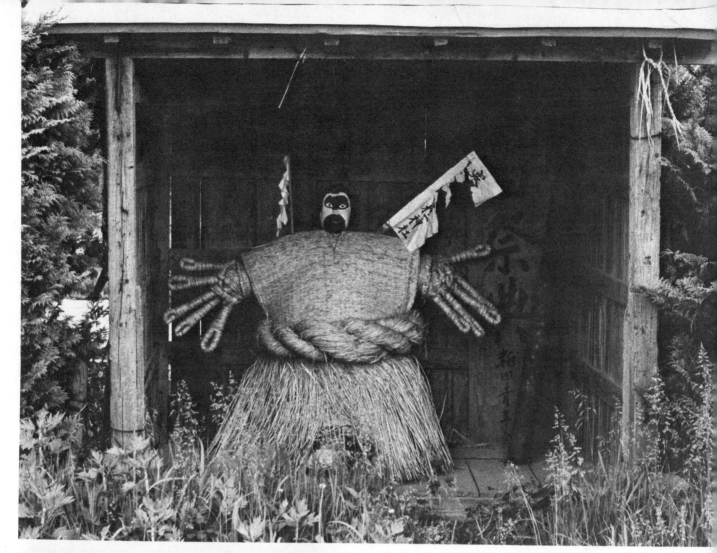

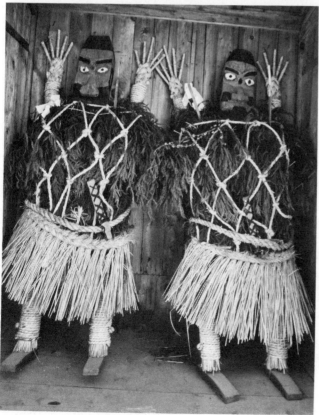

15. *Ningyosawa* (guardian figure), Odate, Akita Prefecture, Japan. A gargantuan-size, rice-straw figure placed at the entrance of the village wards off disasters and diseases. A festival connected with the planting cycle is held twice a year: in the spring after planting of the rice and in the fall after the harvest. A new figure is made for each event. Photograph: Yoshiharu Kamino.

16. *Ningyosawa* (guardian straw figures), Shinubazawa, Odate, Akita Prefecture, Japan. These figures, placed at the entrance of a village to ward off evil spirits, are made with a wooden head and torso of evergreen branches that is spanned by a rice-straw net. A braided rope, similar to a *shimenawa*, is tied around the body of the figure, establishing that the surrounding area is sacred. Photograph: Yoshiharu Kamino.

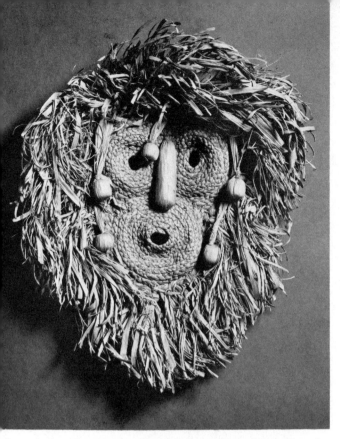
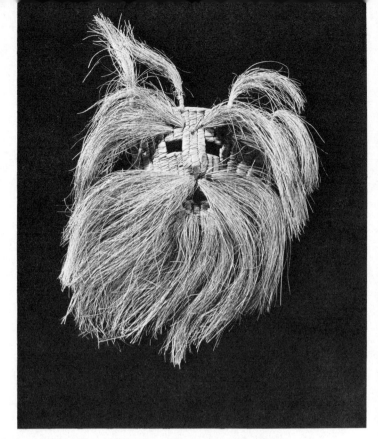

17. Cornhusk mask, Seneca tribe, Great Lakes area. 12" x 10". This mask uses cornhusks in three different ways: stretched to make the nose, shredded for the hair, and tightly braided to form the worn, wrinkled face. Masks of this type, woven by women of the Seneca tribe, were worn by shamans who were usually members of the Iroquois Huskface society. The wearers became the spirits of the harvest, dancing with digging sticks and hoes as part of the New Year's celebration. Collection of the Natural History Museum of Los Angeles County.

18. Dance mask, Taxco, Mexico. 15½" x 14". Shredded palm fibers imitate long, flowing hair, eyebrows, and beard, giving the mask a frightening expression. Collection of Mary Hunt Kahlenberg.

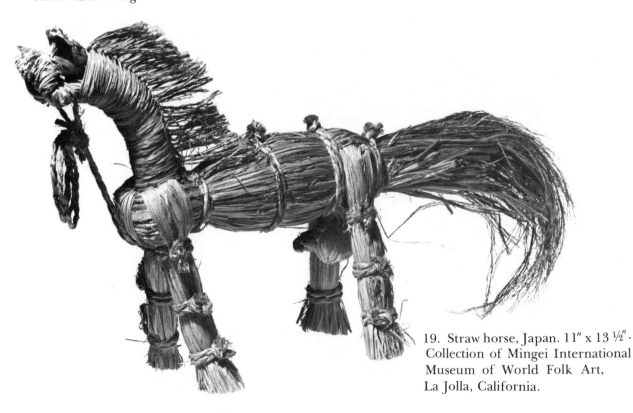

19. Straw horse, Japan. 11" x 13 ½". Collection of Mingei International Museum of World Folk Art, La Jolla, California.

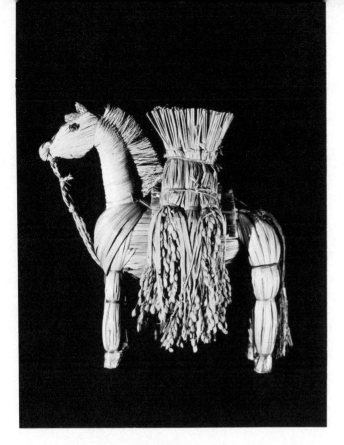
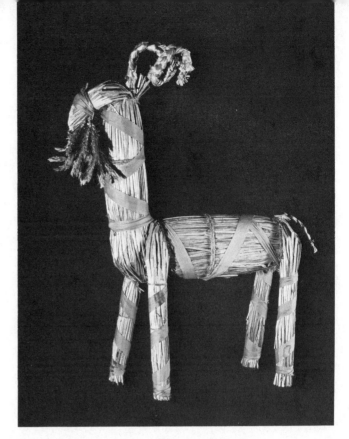

20, 20a, 20b. Straw horse, Japan. 8″ x 8″. Rice-straw horses are made from local materials throughout Japan and typically utilize a combination of binding and braiding techniques. There are many different styles of straw horses, most of them expressing a strong and vigorous character. Within each area the straw horse symbolism is distinct: some are placed on roofs to dispel evil spirits and others, representing the horse as a form of transportation, are made for the spirits of recently deceased persons to ride when they return to ceremonies in their honor. Collection of Marc Treib.

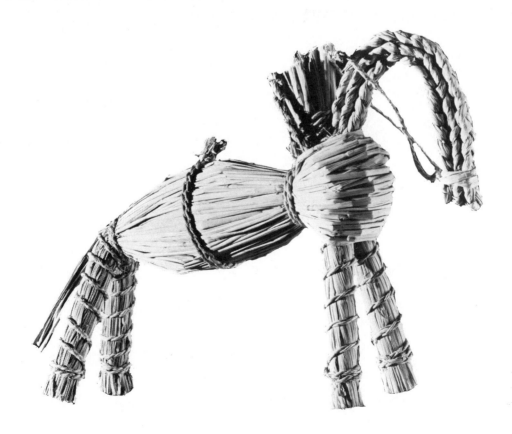

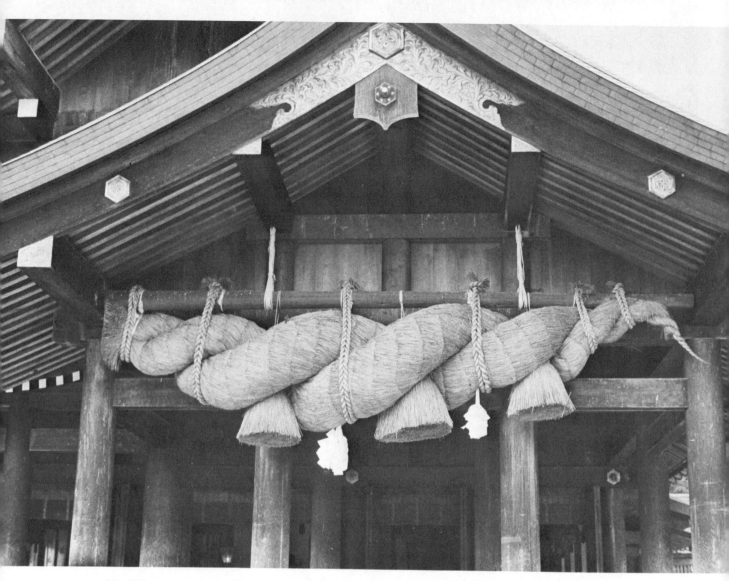

21. *Shimenawa* (sacred straw rope), Izumo Shinto Shrine, Japan. The boundary is an important concept throughout Asia. The myth that tells the origin of the *shimenawa* illustrates this. In ancient times the sun-goddess was abused by her brother, so she hid herself in a cave. As a result, the world was plunged into darkness. The other deities staged a music and dance performance to coax the sun-goddess from the cave. When she heard the music, she was enticed to the entrance of the cave to investigate, whereupon one of the powerful gods pulled her outside. Immediately, another god stretched a rice-straw rope across the cave entrance and beseeched her not to hide again so that the world would not be in darkness. Since then, the *shimenawa* has been used to designate the boundaries of a sacred place or object, whether it be a shrine, temple, tree, rock, or house. It is a sign that the area is pure and exempt from evil spirits. The *shimenawa* at Izumo is the largest one in Japan. Photograph: Marc Treib.

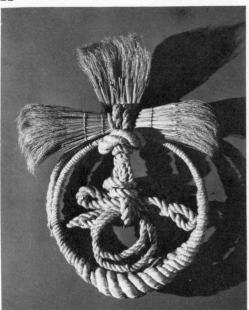
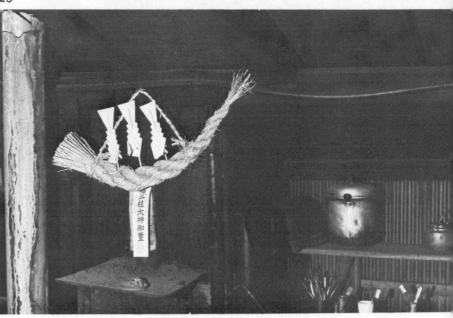

22. *Shimenawa* (sacred straw rope), Tokyo, Japan. 29½″ x 23″ x 6½″. *Shimenawa* styles vary in different areas of Japan. This large knotted form from Tokyo is one of the most dramatic *shimenawa* by virtue of the juxtaposition of a tightly twisted knot with fanning forms at the top. Collection of Harumi Oda.

23. *Kamidana* (New Year's decoration), Fujisawa, Japan. 26″. In the Japanese countryside, *kamidana* are usually made by the farmers for their families. The simple braid is shaped by the tension of the cord from which it hangs. The *gohie*, small strips of angularly folded paper representing offerings of cloth to the deities, look like masts on a sailing ship.

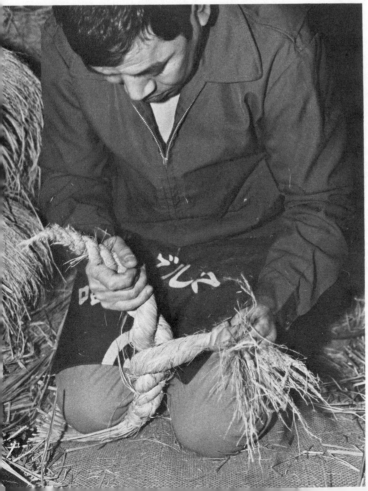

24. The making of a *shimenawa* (sacred straw rope), Kyoto, Japan. First a handful of rough straw is rolled inside a layer of beaten straw. This provides a thick strand with a smooth outer covering. Two of these strands are tied at one end and twisted together by rolling across the leg. A third is added by the same process.

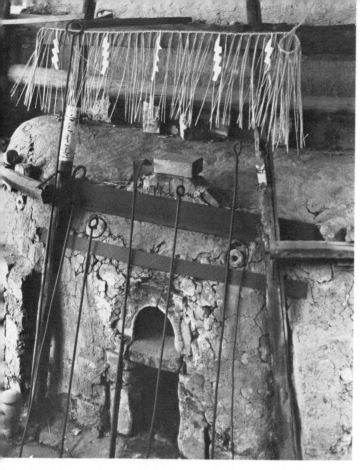

25. *Shimenawa* (sacred straw rope), Kanjiro Kawai's house, Kyoto, Japan. Approx. 72″ x 18″. Another *shimenawa* variation is made by twisting bundles of rice straw into a thin strand and allowing portions of the straw to hang down, thus creating a fringe. Here the *shimenawa* is hung in front of Kawai's kiln in order to ward off evil spirits.

26. Decorative saké bottle stopper (detail), Tokyo, Japan. Approx. 7″ x 13″. These stoppers are used only for New Year's. They are made of split bamboo, bent and tied to create a variety of shapes. Small pieces of gold foil and bright red paper add a festive quality.

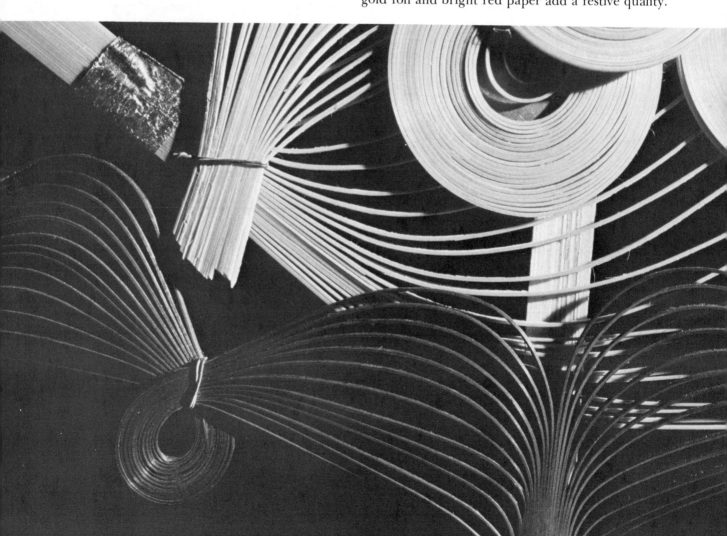

Containers

A bamboo leaf, folded and pinned, is an easy and unpretentious wrapping for a fish. Rice straw is formed into a cradle with a handle for carrying melons. And a piece of bamboo, cut and plugged at one end, will hold water for a day's journey. These simple utensils were probably man's first containers, predecessors of the refined basket and the modern package. Today, we think in terms of cardboard and plastic when we need something to hold or carry objects, never considering that plant material might suffice. Such containers are made quickly with construction methods that maximize the natural physical qualities—strength, length, color, flexibility—of the plant material. These instant containers are beautiful. They remain a shiny bamboo leaf or a golden length of straw, yet at the same time becoming a functional, utilitarian object.

Some simple grass containers are used only once, as we use paper grocery bags. However, the basket can be used permanently. Utilitarian baskets function in daily tasks, storage, and the specialized uses of a developed civilization. These baskets require design, craftsmanship, and strength so that they will remain intact. Thus, the time involved in a basket's construction is usually related to the anticipated length of its use.

Craftsmen generally find basket materials in their own landscape. They know when the grasses should be harvested, how they should be dried, how the outer skin is removed, and how finely to split the plant material to provide sufficient flexibility in the finished product. It takes years of experience for craftsmen to develop this sense of materials.

Throughout the world, areas containing similar plants frequently produce almost identical baskets. Coil construction is a common technique, primarily because it is adaptable to a variety of materials. Grasses are gathered into bundles, which are coiled to form the base. Walls are constructed by the winding of each successive row on top of the preceding one. As they are wound, the coils are bound together by another, more flexible material such as grass, raffia, or cord. In the central core of a coil basket the materials may vary in length, thickness, and strength; it is only necessary that they be pliable. The diameter of this central core or coil determines the thickness of the basket and the fineness of its curve: the thinner the coil, the smoother the surface. The exact placement of coil upon coil, a slow and methodical process, is guided by the skilled hand and the experienced eye of the basketmaker.

The rhythmic lines created by the coil binding are often decorative. A basketmaker sometimes changes the color of the binding materials, creating a stepped design as the coil proceeds row by row. Another decorative technique applied to many types of baskets is embroidery, where a surface design is applied to the surface of the basket.

In contrast to the denseness of a coiled basket, a plaited basket is open and flexible, made with flat, ribbonlike strands of grasses. Similar to a braid in technique, plaiting is a basic over-under-over-under method where two elements of equal structural importance are crossed at right angles.

The plaited basket shown in figure 43 was made by the Japanese craftsman Azuma. He begins a plaited basket by crossing bamboo strips to form a central square grid. Then he bends the ends of the strips diagonally upward and plaits them together, creating a cylindrical shape. This transition from a rectangular bottom to a circular top is characteristic of plaited baskets.

The plaited basket made in Sarawak, Borneo (fig. 41), is an example of plaiting with a thin material. Although utilizing the same technique as the basket made by Azuma, this basket is a

more flexible shape because of the thinly cut cane palm and the fineness of its weave. The pattern created by the light and dark strips is caused by an over-under sequence that allows an element to float over several contrasting strips. Plaited baskets from around the world share this similar patterning; thus such diverse geographic areas as Sarawak, Colombia, and the American South produce similar plaited baskets.

Wickerwork and twined baskets are clearly related to plaited baskets in their construction. They both have a warp and weft, or, in nontextile terms, rigid supports and pliable fibers. In wickerwork the pliable fiber weaves continuously over and under at right angles to the rigid support. The twining technique is the same, except that the pliable elements are crisscrossed after each over-under movement, locking the foundations in place.

Wickerwork and twining may produce either stiff or flexible baskets. As color patterning is seldom possible with these techniques, design interest comes primarily from contrasting the textures of the elements and varying their spacing. Japanese baskets, in particular, utilize the subtleties of this technique. In one basket the basic construction is of bamboo twined together with a vine. Graduated bamboo widths are used to create a horizontal rhythm, while the wickerwork forms a vertical pattern by spanning several bamboo widths. This results in an undulating surface on a rather simple basket shape. The wickerwork is emphasized on the Japanese basket in figure 48 by the technique of burnishing the raised areas, thereby creating many small highlights. Baskets such as these function as flower containers for use in the Japanese tea ceremony and are enjoyed primarily for their aesthetic value.

An appreciation for the visual qualities of basketry has spread to the West in the past few decades. Some basket collectors are primarily interested in the specific cultures that produced the baskets, whereas others value and collect basketry for its aesthetic qualities. Whatever their initial interest, both groups are saluting the skills of the basketmaker who has guided the natural qualities of plant materials into beautiful and functional objects.

27. *Til* (backpack basket), Aha, Kunigami-son, Kunigami-gun, Okinawa Prefecture, Japan. The basketmaker is attaching the top binding to a backpack basket made entirely of split bamboo. Photograph: Kazuyoshi Kudo.

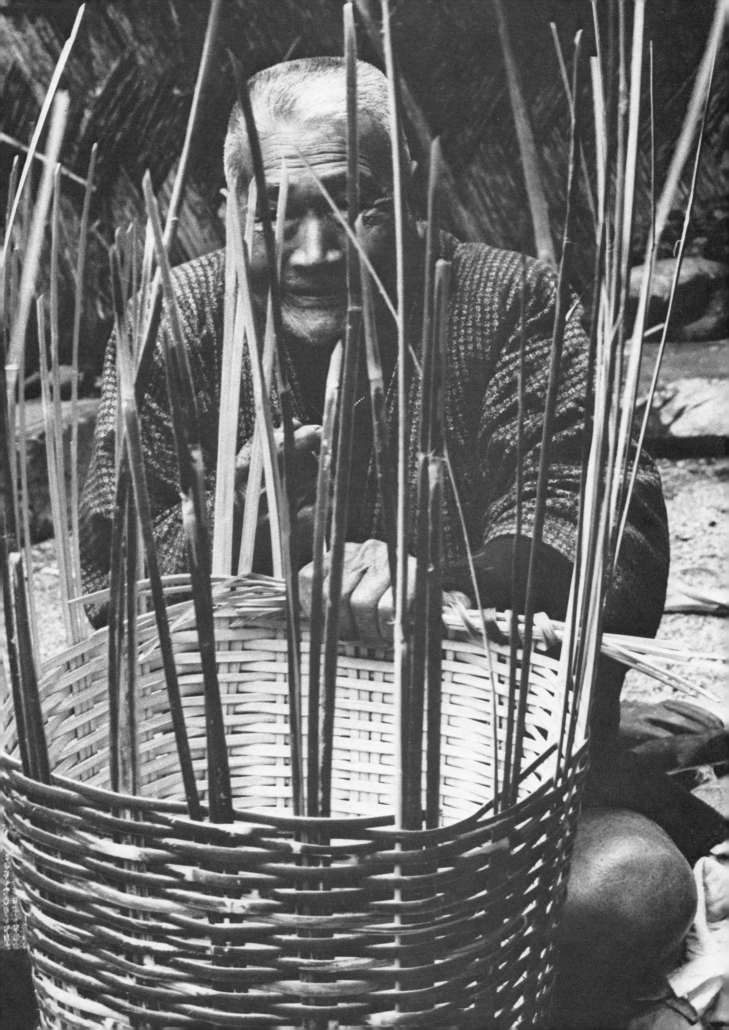

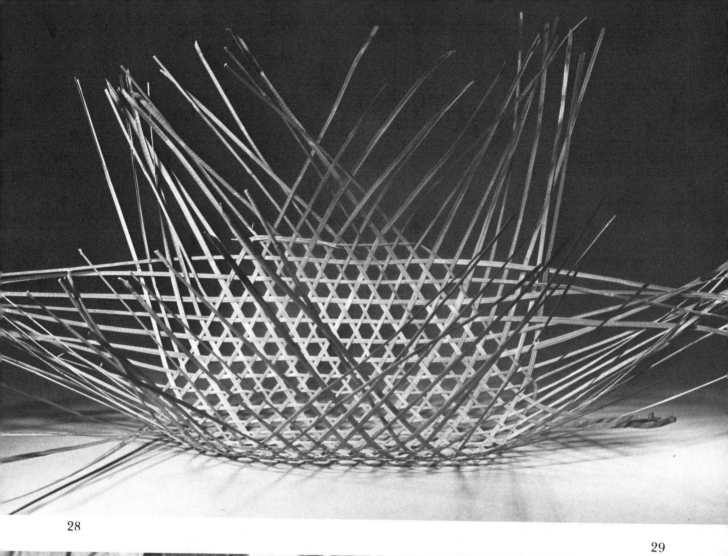

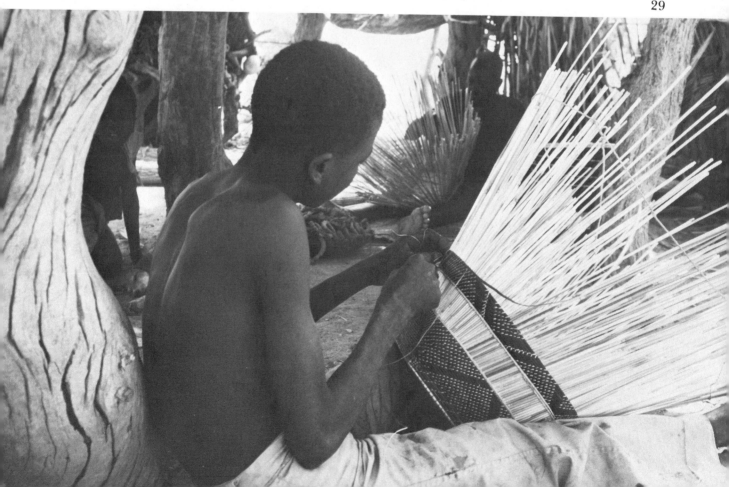

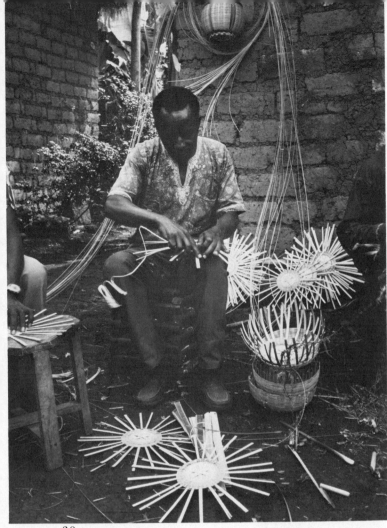

30

31

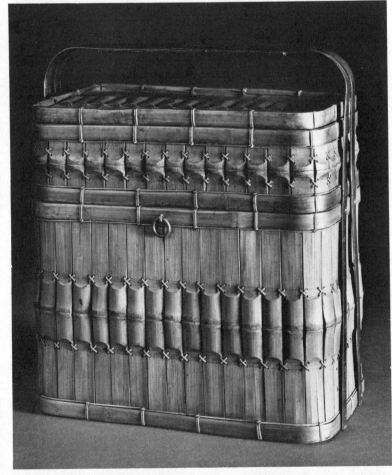

28. *Nicago* (basket for cooking fish), Matsumoto, Nagano Prefecture, Japan. 9″ x 39″. Thin sugar bamboo strips are loosely plaited into a basket for cooking fish. The fish and basket are then lowered into boiling water. The open structure allows the fish to cook without falling apart.

29. Market basket, Mossi people, Upper Volta, Africa. Made by the Mossi people in the vicinity of Ouagadougou, this basket is made in the wickerwork technique from cane bound with raffia palm. The unwoven area provides a contrast of texture and color without weakening the basket. Photograph: Peter Nelson.

30. Basketmaker, Buli people, Western Cameroon. The bottom of these simple, round baskets is made first. The supporting ribs are crossed and then finer bamboo is woven between them. The sides of the basket are shaped next and a sturdy rim is added to the top. The baskets are made in graduated sizes. Both the shape and the materials of these baskets make them functional and long lasting. Photograph: Peter Nelson.

31. Food-carrying basket, Japan. 11½″ x 11″ x 6″. This handsome, sturdy box is simply and elegantly detailed. In fashioning this basket the top of the bamboo was sliced off, leaving only the area around the node. This created rows of varied texture and dimension. The points of intersection are emphasized by the crisscross binding. Collection of Nancy and Richard Bloch.

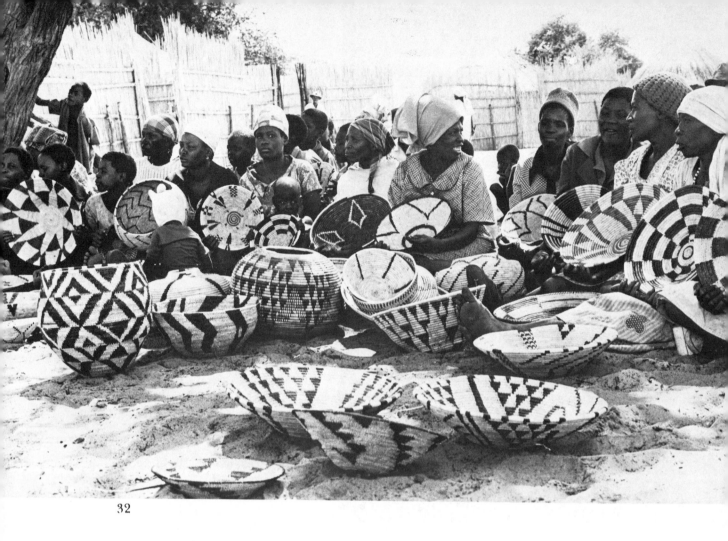

32

33

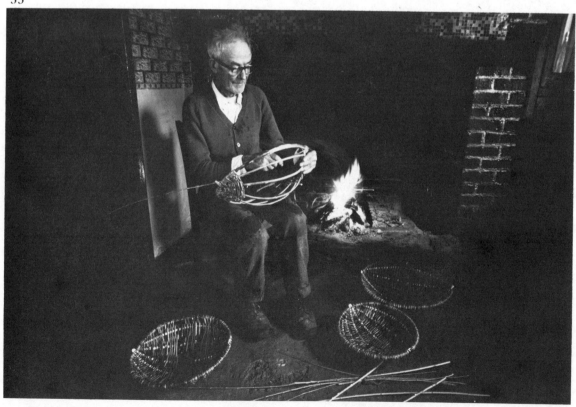

32. Market day, Yei people, Ngamiland, Botswana. Every few months buyers from the National Craft Service arrive to purchase baskets. Women gather from surrounding areas to sell the baskets that they have made, and the buyers purchase those showing the best technical skill and most pleasing design. While there is a tradition of basketry in Botswana, there has been a considerable renaissance in the past few years because of the government's encouragement of crafts as articles of international trade, and basket sales have stimulated the local economy. These baskets, made in the coil technique, have cores fashioned from the dried stems of palm leaves, which are wrapped with split palm leaves. Some leaves are dyed brown with a dye made from a combination of root bark and mulch. Photograph: Michael Yoffe.

33. Basketmaking, Ireland. A farmer often spends his winter evenings making baskets. The frame is made from twigs and local rush is woven between them. The uneven coloring produces a banded design.

34. Baskets for collecting mushrooms, Kyoto, Japan. Skinned and unskinned bamboo provide a beautiful contrast in textures. The long handle is perfect for carrying, and the small feet keep the basket upright when it is set down.

34

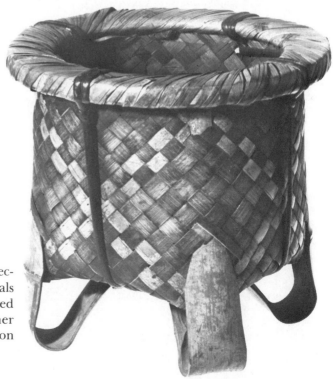

35. Charcoal basket, Kyoto Prefecture, Japan. 9¼" x 10". Hot coals from the fire are placed in this lined basket. It is used as a hand warmer during the winter months. Collection of the Kyoto Prefecture Museum.

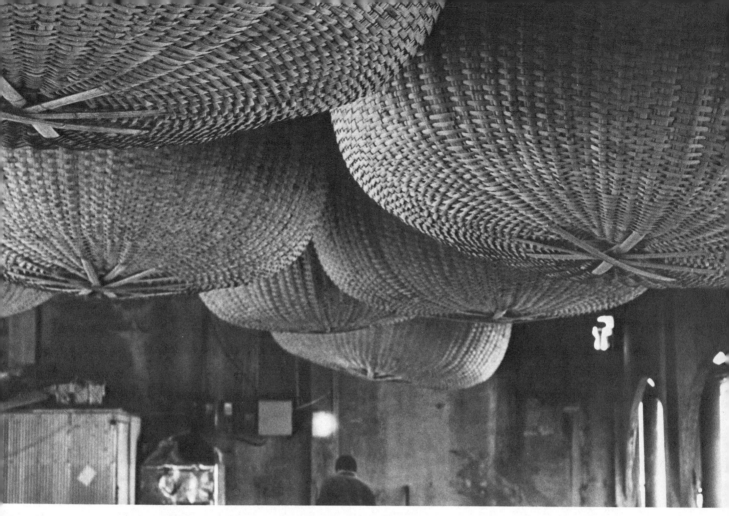

36. Fishing baskets, Susaki, Kochi Prefecture, Japan. Made of long-jointed bamboo, these fishing baskets are a type of chum basket that holds the sardines used as live bait on bonito-fishing expeditions. The baskets are hung from the ceiling when not in use. Photograph: Kazuyoshi Kudo.

37. Storage basket, Kuro Shima, Taketomi-cho Yaeyama-gun Okinawa, Japan. Approx. 23⅝″. This large grain-storage basket is fashioned in the coil technique. Rough netting that provides handholds covers the surface of the basket. Photograph: Kazuyoshi Kudo.

38. Basket, northern Sudan. 24″ x 17″. This large, lidded basket is made of grass coiled with brightly colored palm strips. The tightly woven geometric designs resemble rugs woven in the same area.

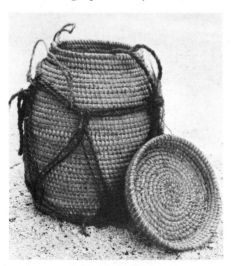

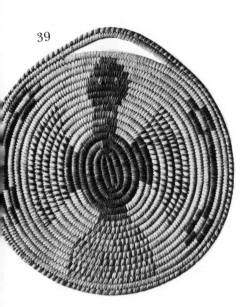

39

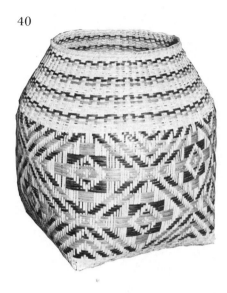

40

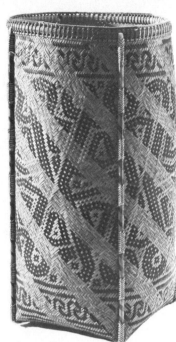

41

39. Plaque, Papago people, southern Arizona. 14″ x 13⅝″. This plaque is made with a coiling technique. A handful of grass is wound into a spiral form, and held in place with a yucca wrapping. The dark wrapping forms the image of a bird in flight. Collection of Mary Hunt Kahlenberg.

40. Basket, Cherokee people, Oklahoma. 17½″ x 14″. This basket is covered with diamonds and crosses in alternating color bands. Made in a traditional twill technique from a type of river cane, it was probably a storage basket. Collection of the Maxwell Museum of Anthropology, Albuquerque, New Mexico.

41. Backpack basket, Sarawak, Borneo, Malaysia. 14″ x 4″. This sturdy but flexible basket is made with a diagonal plaiting technique. Both top and bottom are made of *rotang*, a cane-palm fiber; the bottom is separate and considerably stiffer than the sides, which helps the basket to retain its shape. In addition, if the bottom wears out, it can be replaced. Collection of Mary Hunt Kahlenberg.

42. Bag, Nez Percé people, American Northwest. 24″ x 20″. The Nez Percé were a native American Indian people who roamed the area that is now Idaho, Oregon, and Washington. They hunted, fished, and gathered fruits, carrying home their food in large, flexible woven bags. Tribeswomen made the bags from the inner bark of the Indian hemp plant, twisting individual bark strands and then twining them together. A covering of loosely twisted, dyed cornhusks was woven into the surface for decoration. The Nez Percé had an eclectic design repertoire that borrowed heavily from other tribes. The strongest influence came from the Plains Indians, whom they encountered during buffalo hunts on the prairie. Nez Percé bags were characterized by the same strong, simple, patterns used by the Plains Indians. Collection of the Southwest Museum, Los Angeles.

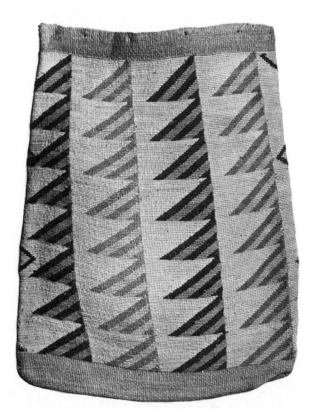

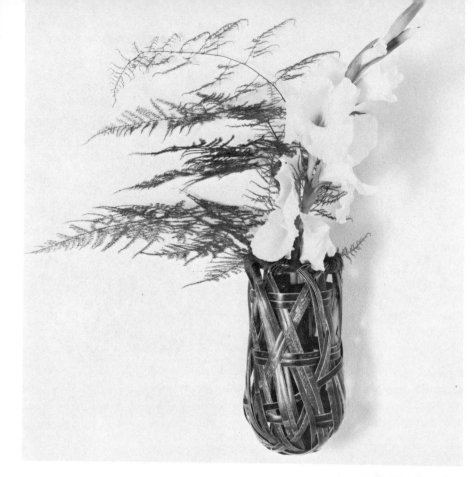

43. Tea-ceremony basket, Chikensai Azuma, Kyoto, Japan. 7½″ x 3⅝″. The rough, loose construction of this basket satisfies the Japanese tea ceremony's requirement that an object of admiration be unassuming, straightforward, and modest.

44. Chikensai Azuma, Kyoto, Japan. Azuma is one of Japan's foremost basketmakers. As a child, Azuma wanted to become a painter but was discouraged by his father. Instead, he apprenticed himself to a local basketmaker, learning traditional basket forms and techniques. After becoming established as a traditional basketmaker, Azuma sought new ways of expression by inventing new forms. Whereas baskets had always been designed to hold floral arrangements, Azuma's innovative designs (see fig. 46) are intended to be sculpture rather than flower containers.

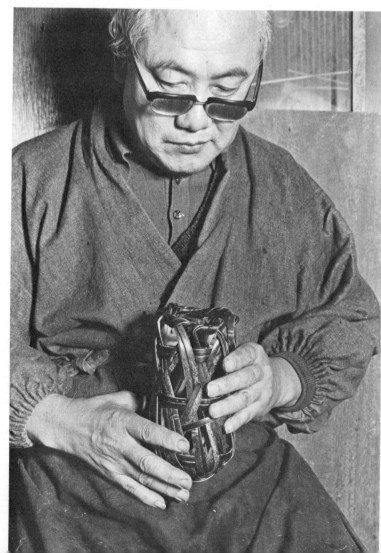

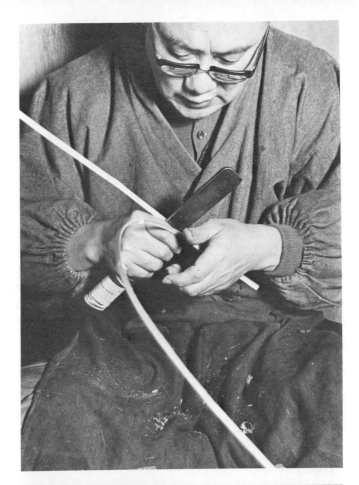

Construction of a tea-ceremony basket. In this series of seven photographs Azuma is seen making a simple plaited basket to be used as part of the tea ceremony. Azuma's work space is a small room about six by twelve feet at the rear of his house. He begins his work by selecting bamboo of the desired color and size. He splits these bamboo lengths and soaks them for a period of several hours.

45. After the bamboo has become flexible, he begins to split it further with a knife.

45a. He takes another knife and trims off the outer skin.

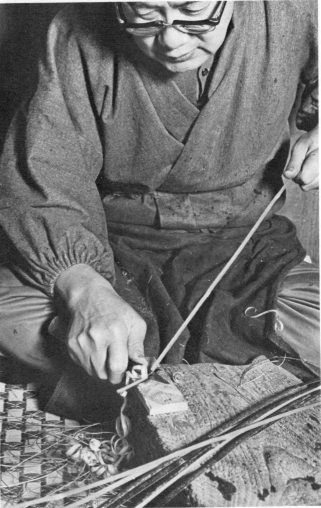

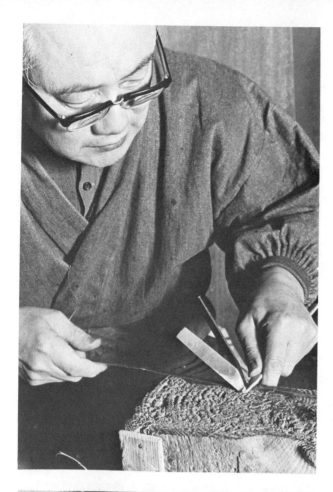

45b. He trims a strip to the desired width by pulling it through a jig made of two knives pounded into a wooden block. Azuma produces different widths by varying the placement of the knives.

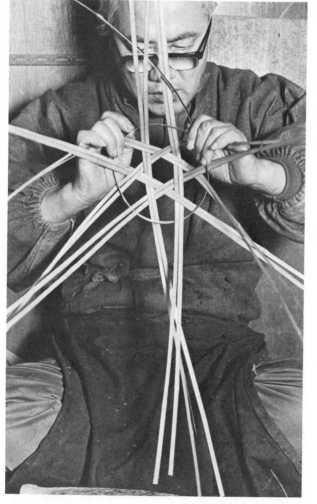

45c. He begins the actual basket by crossing six pairs of strips. Here, he checks each pair to make sure they are of equal length and that the crossed star shape is centered. These six elements will become the frame of the basket.

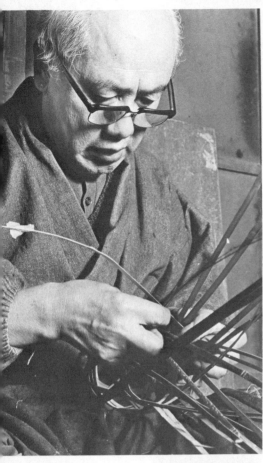

45d. Then with six-foot lengths of thinner, well-soaked (two to three hours) bamboo strips, he begins to plait the basket into a cup shape.

45e. He continues to plait, adjusting the shape as the piece grows. When he has achieved the basic shape, he secures it by taking the ends of the original six elements and weaving them diagonally back through the basket to the bottom.

45f. A soft strip of bamboo is then twisted around the basket rim. This firms and maintains the shape. Azuma earns his living from the production of these baskets rather than from his refined sculptural forms (see fig. 46). He is generally able to produce three of these baskets a day.

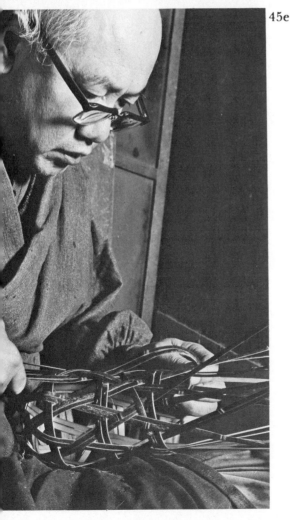

45e

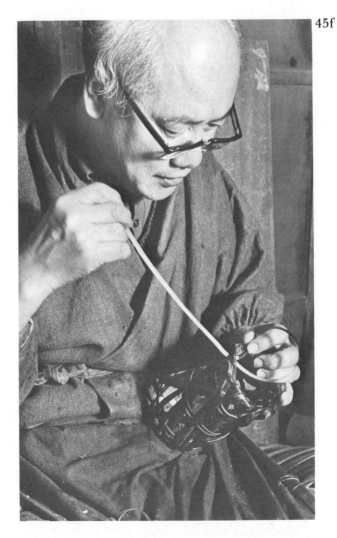

45f

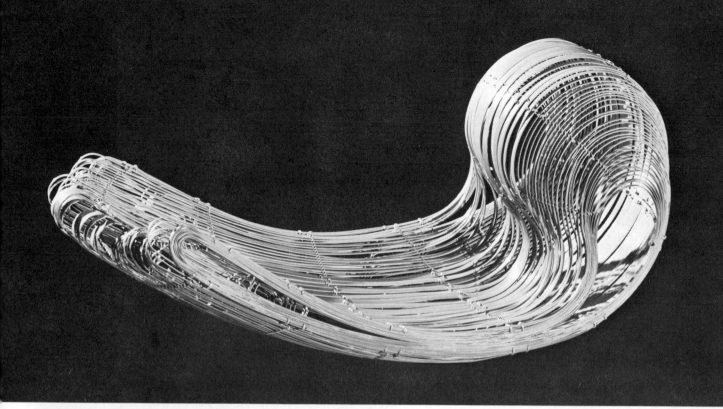

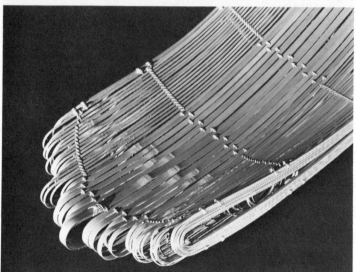

46, 46a. Wave-form basket and detail, Chikensai Azuma, Kyoto, Japan. 42″ x 14″. Azuma has expressed the fluidity and movement of an ocean wave with a large, curving form and a surface composed of small, tightly curving bands.

48. Basket, Japan. 18″ x 10¾″. This basket is reminiscent of bramble, an effect consciously achieved by using an irregular plaiting technique and pinching the circular shape in at front and back. The craftsman also achieved a feeling of natural growth by burnishing the ridges of the bamboo strips, thereby highlighting the varied angles of the plaiting. Large pieces of bamboo and tree branches surface in the recessed areas. Collection of Nancy and Richard Bloch.

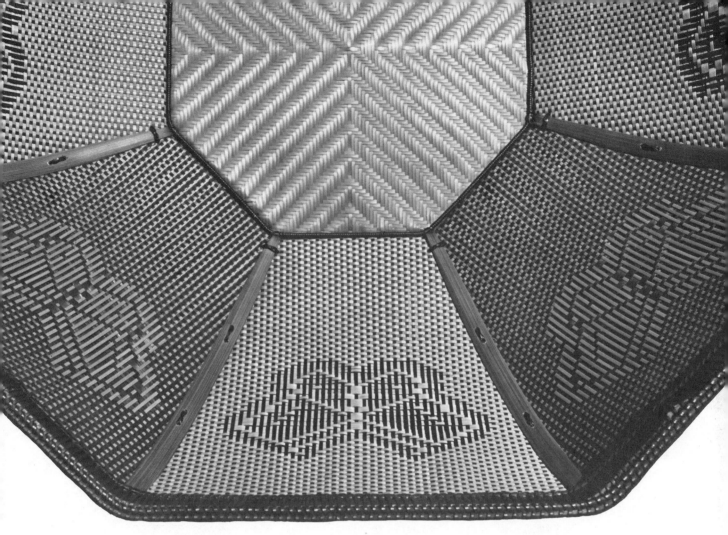

47. Basket (detail), Chikensai Azuma, Kyoto, Japan. 14″ x 14″. In a more traditional style Azuma weaves an extremely precise octagonal basket.

49. Covered box, China, Ching dynasty (1644–1912). 4¾″ x 3¼″. In China bamboo carving was known as early as the Sung period (960–1279), but it was not until the Ming dynasty (1368–1644) that it developed into a major artistic medium. At this time two distinct styles developed: one advocated simplicity of design with shallow carving (using the knife as though it were a brush), the other admired the deeper, robust technique seen on this covered box. Leaves, flowers, and insects wrap around the sides and top. Collection of Mr. and Mrs. Cardeiro.

50. Brush holder, China. Ching dynasty (1644–1912). 6½″ x 5¾″. Special knowledge was essential for the bamboo carver: the proper selection of material (realizing the potential of a certain piece of bamboo), skill with the knife, and an understanding of literature, painting, and calligraphy (references to other arts were of utmost importance). The landscape and figures on this brush holder are carved from a single bamboo root. The holes behind the carving hold the brushes. Collection of David Kamansky.

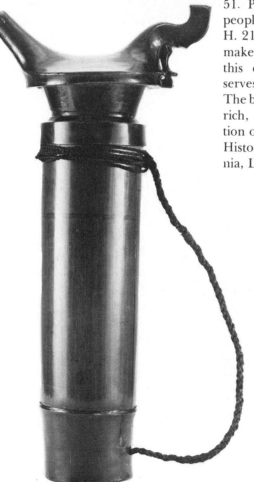

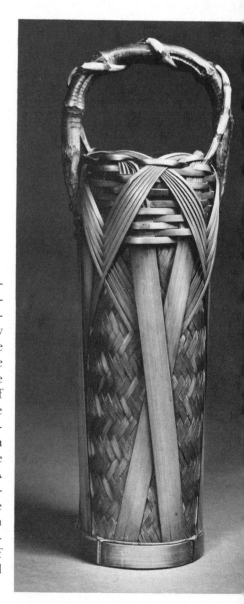

51. Palm wine container, Batak people, Sumatra, Indonesia. H. 21″. A large bamboo section makes a simple container; on this container case the node serves as a ready-made bottom. The bamboo is stained to give it a rich, dark appearance. Collection of the Museum of Cultural History, University of California, Los Angeles.

52. Basket for flower arranging, Japan. H. 21⅝″. This basket displays the beauty and versatility of bamboo as a basketry material. The tubular part of the basket is plaited, and two wide strips cross front and back at the top to give a visual emphasis of strength and height. These strips then divide into six sections and are twisted and woven back into the basket, echoing the diagonals of the solid strips. A handle wrapped with vines emphasizes the rustic aspect of the basket, which is stained a rich red-brown. See plate 31 for a detail of this basket. Collection of the Field Museum of Natural History, Chicago.

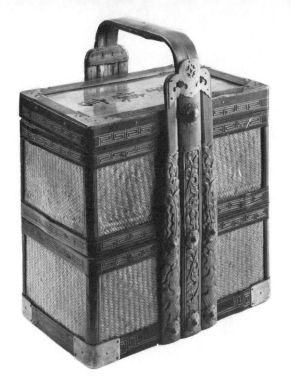

53. Picnic basket, Ningpo, Chekiang, China, 19th century. 14″ x 10½″. An ancient Chinese proverb cautions men and women against the touching of hands, suggesting that a gift from a man to a woman be presented in a basket. Baskets have been made in China since ancient times. One important basket-producing area was the Yangtze valley and southward, where baskets were made for traveling, picnics, and flower arrangements.

This tiered, rectangular picnic basket has two compartments with a shallow tray dividing them. The interior and exterior walls are woven individually. The outer portion (shown in the photograph) has a twill wall trimmed with bamboo strips carved in a key pattern and dyed black and is fitted with metal trimmings and a lock. The bamboo handle is carved with detailed floral designs and the symbols of the Eight Immortals, a group of Taoist holy men admitted to eternal life as a reward for good acts on earth. "Act rapidly and talk right and carefully" is the message written on the lid of the basket. Collection of Ruth Schierson.

54. Straw marquetry chest, English, 18th century. 5¼″ x 8¾″. Straw marquetry was popular in England and France in the eighteenth and nineteenth centuries. Flattened filaments of wheat and oat straw were split and glued onto wooden objects such as tea caddies, trinket boxes, bookcovers, and fire screens. Sometimes designs were taken from contemporary prints, as was probably the case with the radiating design on the front of this box, which is a particularly attractive feature that emphasizes the curve of the top. A large quantity of straw marquetry was done by French prisoners of war in England between 1765 and 1815. Collection of The Metropolitan Museum of Art, New York; Bequest of Stephen Whitney Phoenix, 1881.

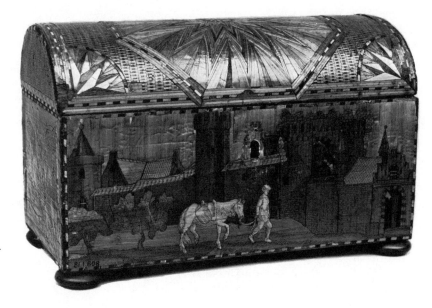

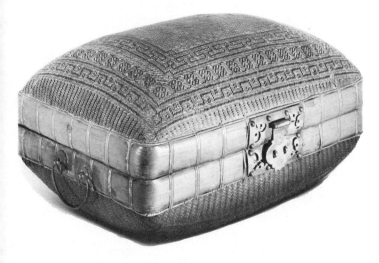

55. Trunk, China, 19th century. 24″ x 16″ x 12½″. Considering the hazardous life a piece of luggage leads today, it is almost impossible to think of setting out on a journey with this exquisite bamboo trunk. Two wide red-stained bamboo strips form the frame, and the covering is plaited with a series of geometric border designs. Collection of Raymond and Keith Antiques.

Adornment and Apparel

The animal hide worn by the caveman is our most vivid image of primitive clothing. Indeed, skins were the common garb in temperate climates, but in the tropics grass skirts were, until relatively recently, in fact, the standard dress. Surprisingly, the term *grass skirt* is a misnomer because this swinging, swaying, sexy garment of the tropics is actually made of palm. Individual palm fronds are attached to a waistband with a variety of knots and plaiting techniques. Moving freely around the body, the skirt is a lightweight, well-ventilated covering. In both Africa and New Guinea grass skirts are still worn for ceremonial dances.

The Japanese traditionally fashion rice-straw raincoats, made to last only a single rainy season. Some are as simple as grass skirts and others consist of individual layers of straw knotted onto a grass net ground. Similar garments are made in southern Europe and Central America.

Grass sandals (figs. 58 and 59), with woven soles and straps or ties, are common in tropical climates, and thick overshoes are worn in snowy areas. Winter overshoes are several layers thick to provide insulation; the glossy skin of the straw makes them water repellent. In Europe oversized straw boots were once worn over snow boots for riding in a sleigh. In Japan a fringe was added at the top of boots to keep out snow. The pure functionalism of straw footwear makes straw boots from Europe almost indistinguishable from those of the Orient.

Although the garments are no longer extant, grass and fiber clothing was worn in antiquity. A tomb painting in Thebes and a fresco in Pompeii depict straw hats. Other records indicate that ancient Arabs, Greeks, and Etruscans all made use of similar materials. Straw and palm were obvious choices for clothing, as those plants were plentiful in the landscape. For the same reason grass garments were almost exclusively worn by commoners and shunned by the upper classes. This attitude did not include the straw hat, an item within the capricious realm of fashion. A straw hat is made by sewing together and shaping long, plaited bands. In Tuscany, where the straw hat is thought to have originated, shiny spring wheat was used to make what is known as a leghorn plait.

Although its visual appeal made it an object of fashion, the hat began humbly as a sunshade for laborers who spent long hours in the fields. Late eighteenth-century romanticism created a fashion for flat, wide-brimmed straw hats with a wide silk ribbon passing over the crown and tied under the chin, bending the brim toward the cheeks. By the nineteenth century the hat had such widespread appeal that straw-plaiting centers were located in England, France, Switzerland, and Italy. The long plaits were made mostly by women and children working at home. The plaits were either sewn or tucked together as the plait was wrapped. The finished hat form was then stiffened in a gelatin solution, dampened with steam, shaped on wooden blocks, and dried. During the Victorian era the wedding-cake approach to decoration was also applied to straw hats. Clusters of straw flowers and straw lace adorned the brims of bonnets.

Lace, often made from linen (a plant closely related to the grass family), peaked in popularity during the last half of the nineteenth century. At the same time lace made from straw became fashionable. (To make straw lace, the straw is finely split and worked with techniques similar to those used for linen lace.) Detailed ornaments were in vogue, so painstakingly crafted that they became extraordinarily elaborate (fig. 83). The golden sheen of the straw also suited the needs of other accessories such as collars, brooches, and even the applied decorations on ecclesiastical garments. At the end of the nineteenth century straw lace became less fashionable and this, coupled with escalating labor costs and the development of synthetic straw, virtually eliminated its production.

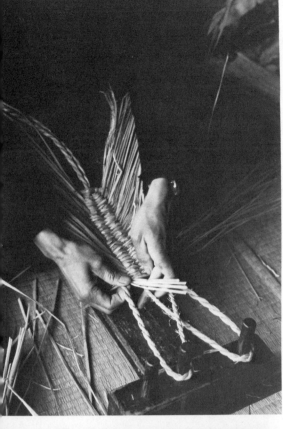

56a

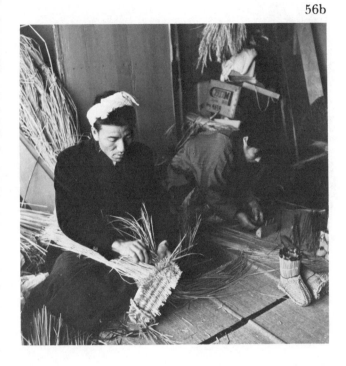

56b

56a, 56b, 56c, 56d. The making of straw boots. Akazawa, Tokamachi, Niigata Prefecture, Japan. Long pieces of rice straw are used to make snow boots. A frame holds the tension of the foundation braids, and barely unbeaten straw is woven over them. After the sole has been formed, the ends are cut. The top portion of the boot is made separately and attached to the sole. Photograph: Kazuyoshi Kudo.

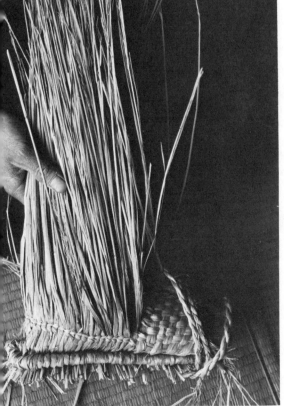

56c

56d

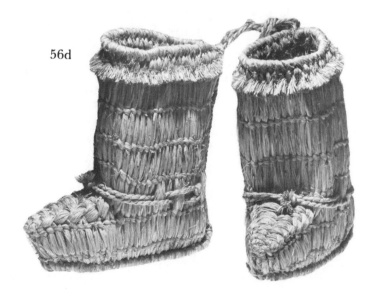

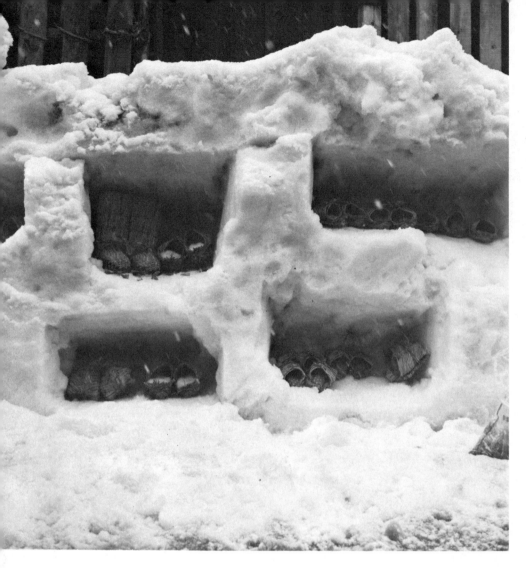

57. Snowshoes, Tokamachi, Niigata Prefecture, Japan. Rice-straw boots and shoes are protected in cubbyholes carved into a snowbank. Boots are worn for deep or new snow while shoes are made for walking on packed snow. Straw footwear is frequently custom made. Photograph: Kazuyoshi Kudo.

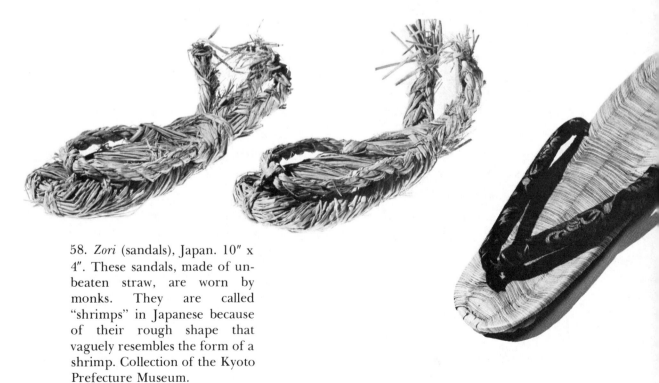

58. *Zori* (sandals), Japan. 10″ x 4″. These sandals, made of unbeaten straw, are worn by monks. They are called "shrimps" in Japanese because of their rough shape that vaguely resembles the form of a shrimp. Collection of the Kyoto Prefecture Museum.

60. Straw mittens, Kumozawa, Akita Prefecture, Japan. 8″ x 4″. These plaited rice-straw mittens may not provide the flexibility of those made of wool, but they provide considerable insulation.

61. Raincoat, Japan. 32″ x 24″. This raincoat looks like a suit of armor. Flat, stiff rice straw is woven for the back and the roots are left unbound for a winged effect. Collection of the Ethnographic Museum, Osaka, Japan.

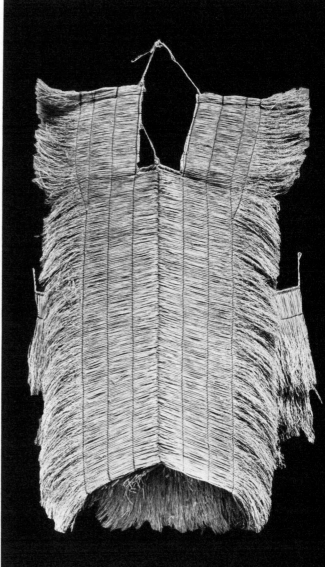

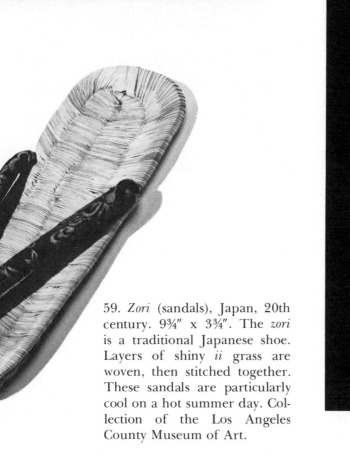

59. *Zori* (sandals), Japan, 20th century. 9¾″ x 3¾″. The *zori* is a traditional Japanese shoe. Layers of shiny *ii* grass are woven, then stitched together. These sandals are particularly cool on a hot summer day. Collection of the Los Angeles County Museum of Art.

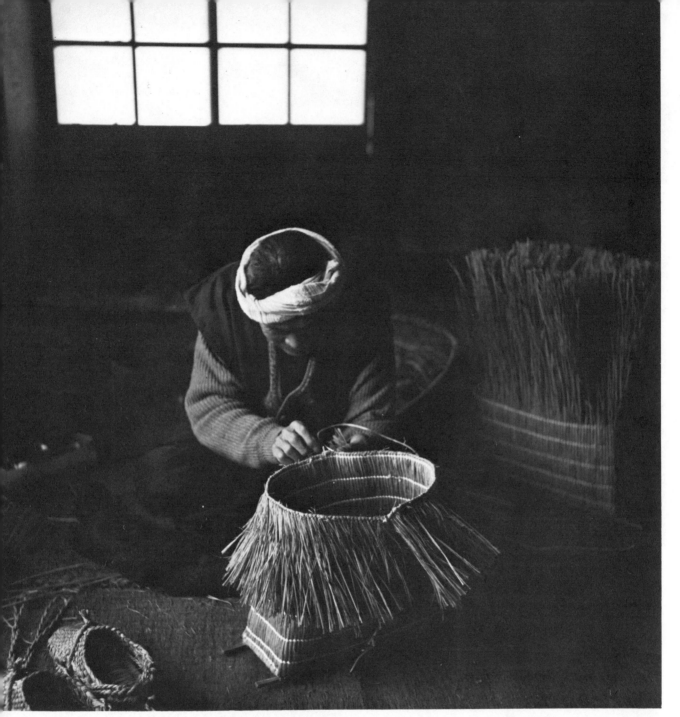

62. Straw bag, Kaizaka, Tsunan-cho Nakauonuma gun, Niigata Prefecture, Japan. The process for making this bag is similar to that for making straw boots. Long lengths of rice straw are twined together. Two wooden strips guide the shaping of the bag. Photograph: Kazuyoshi Kudo.

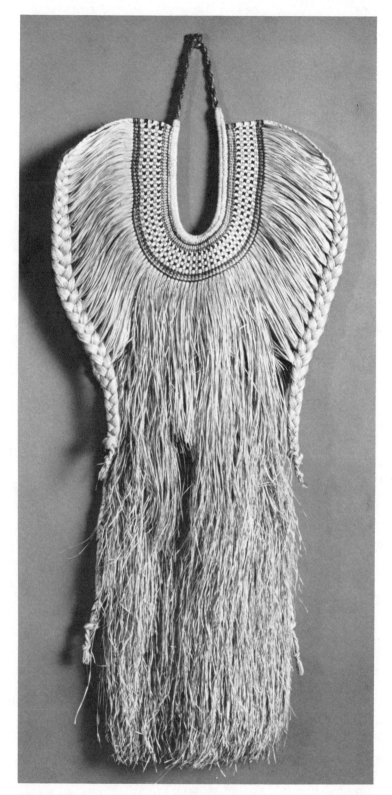

63. Raincoat, Japan. 44″ x 23″ x 2″. The raincoat is seasonal in two senses: it is made for the rainy season and lasts only a single season. In the area around the neck where it will get the most wear the straw is woven together with cotton threads. Two braids on the side define the shoulder area. The straw covering the back is tied to a straw net; the covering is several inches thick. Collection of the Cleveland Museum of Natural History.

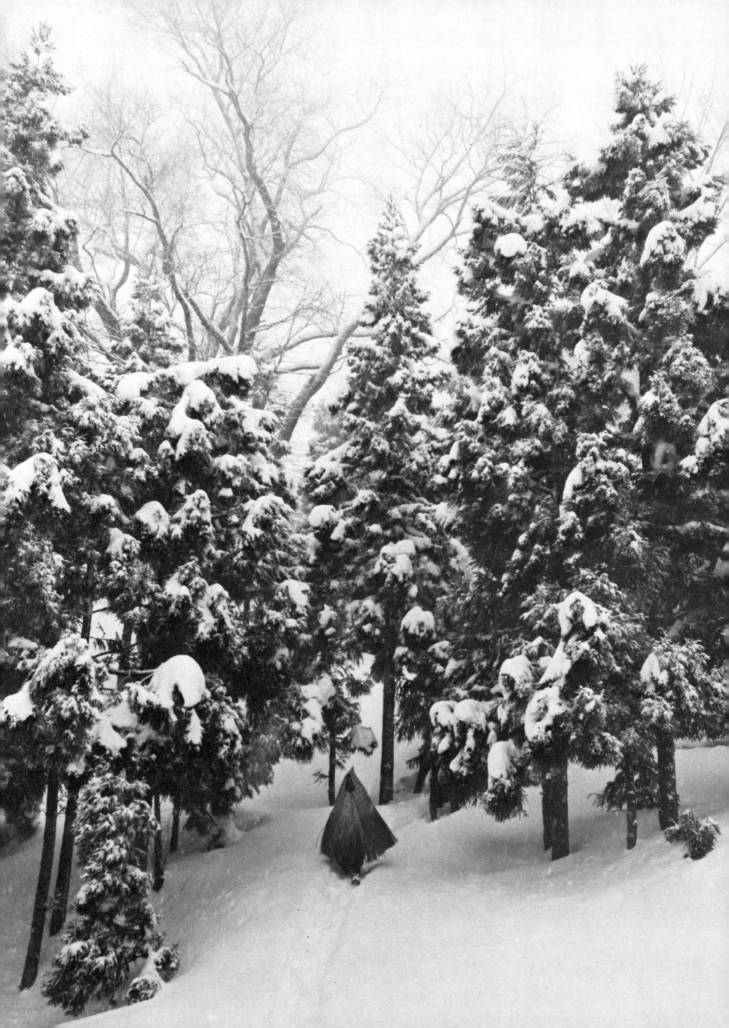

65. Sun or rain hat, Tokuno Shima-cho, Oshima-gun, Kagoshima Prefecture, Japan. An efficient hat is made by stretching the leaf of a Kuba palm tree over a bamboo frame and securing it with an outer rim of bamboo. Photograph: Hitoshi Uezu.

66. Farmer with bocchi rice-straw hat, Harita, Chiba Prefecture, Japan. The stem of the rice plant provides the material for many functional items in Japan, among them this rice-straw hat. It completely shades the face of this farmer as she stands in the hot summer sun. Photograph: Yoshiharu Kamino.

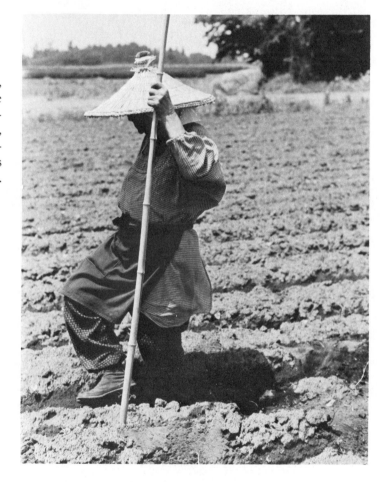

64. Snow coat, Akakura, Tokamachi, Niigata Prefecture, Japan. A local sedge plant with a slick and waterproof outer skin provides the material for this coat. The wearer appears almost like part of the forest as he moves through the trees. Photograph: Kazuyoshi Kudo.

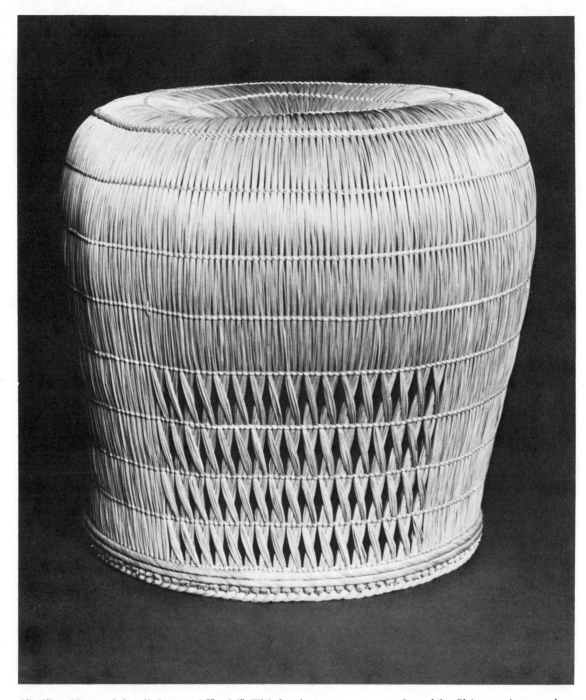

67, 67a. Hat and detail, Japan. 16″ x 14″. This hat is worn as a type of mask by Shinto priests as they go from house to house asking for alms. The priests announce their arrival by playing a flute (sticking out from under the hat). The detail photograph shows the open twined area that allows the priests to see through. Collection of the Mingei Foundation, La Jolla, California.

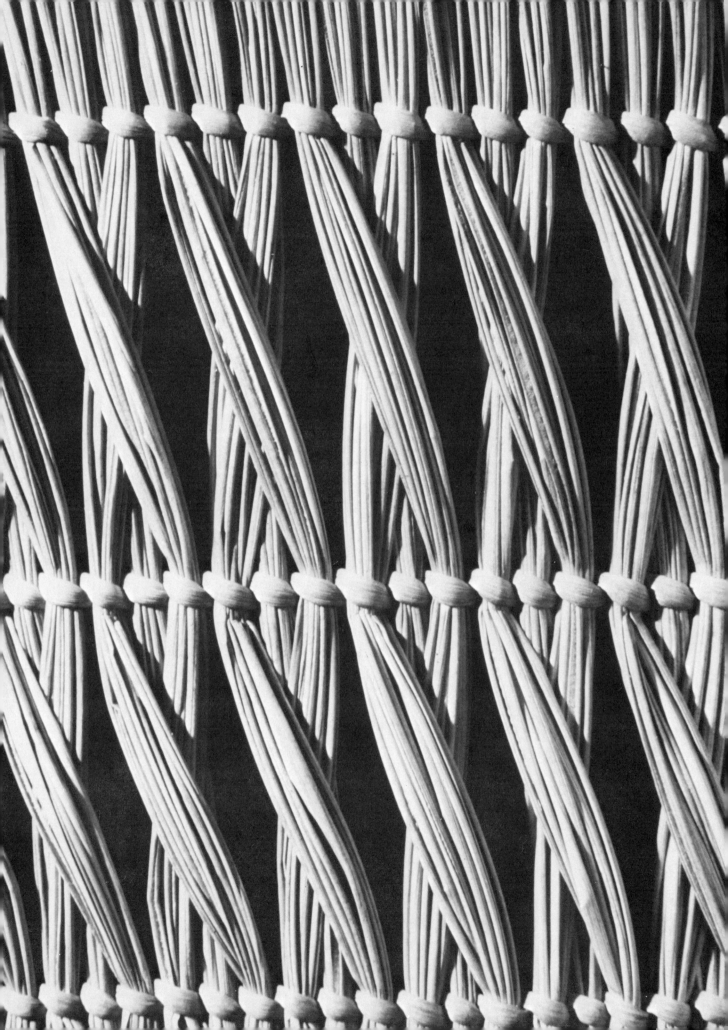

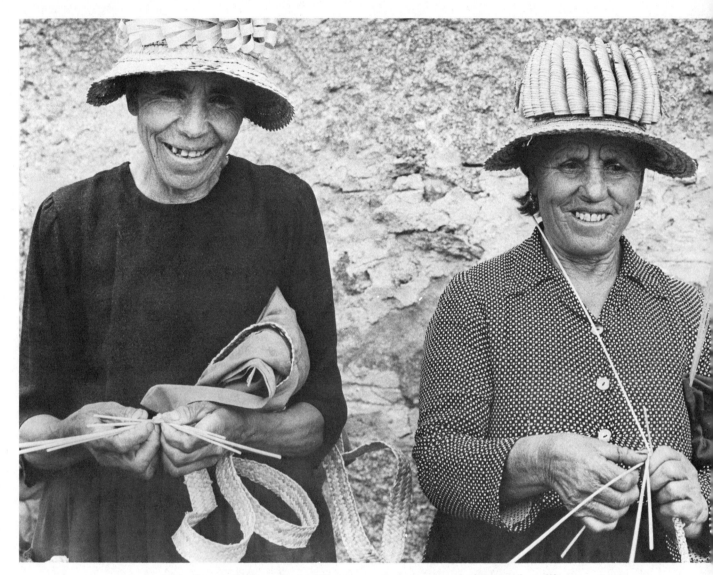

68. Straw plaiters, Spain. These two women wear their straw hats like an occupational badge. Their hands are busy making the straw plaits that will later be sewn together to form another hat. Photograph: Brigna Kuoni.

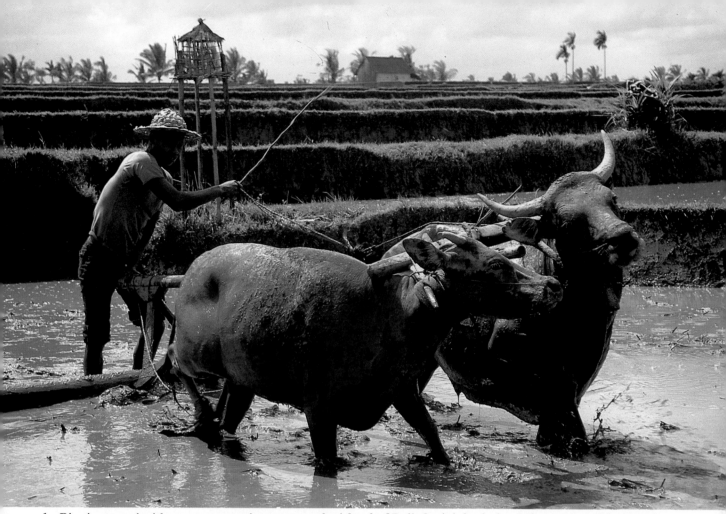

1. Rice is treated with reverence and respect on the island of Bali, for it is both the major source of food and the basis of the Balinese economy. At planting time the land is tilled repeatedly. Plows are pulled by water buffalo; weeds and rice straw from the paddy serve as fertilizer.

2. The "mother" seed, chosen from the finest stalks of the previous rice crop, is sown in a small nursery plot.

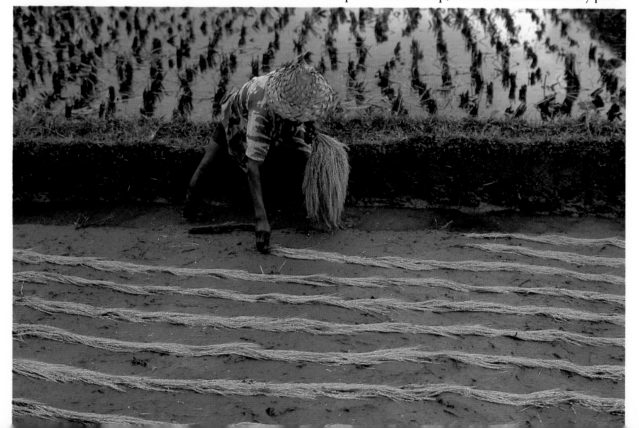

Printed in Hong Kong by South China Printing Co.

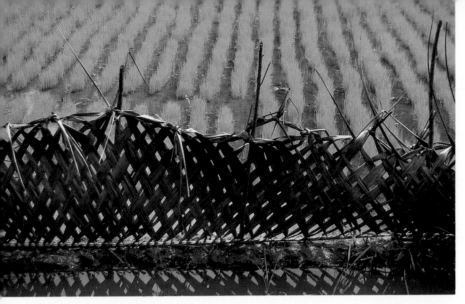

3. Protected by a palm fence, the rice seedlings grow for approximately two months until they are large enough to be transplanted.

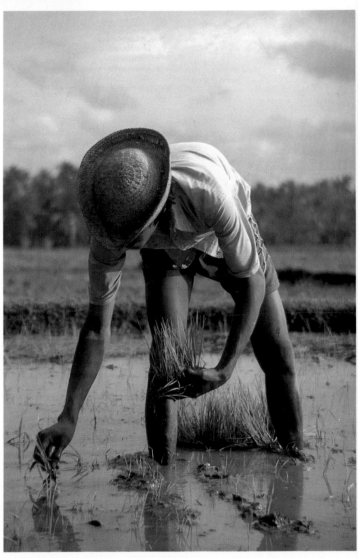

4 and 5. The first nine seedlings are planted according to Balinese ritual. The remainder of the plants are stuck into the mud in rows at intervals of one handspan.

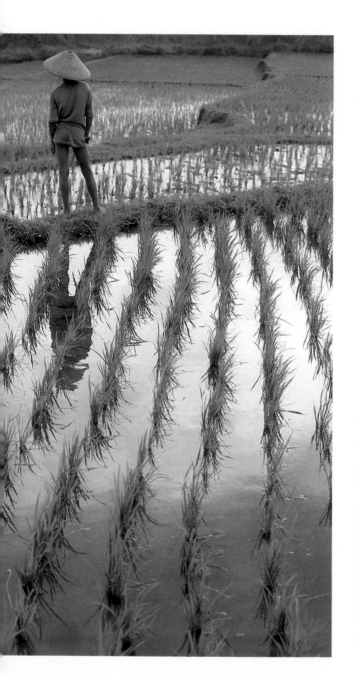

6. Two days before the rice is harvested offerings of food are left in the fields.

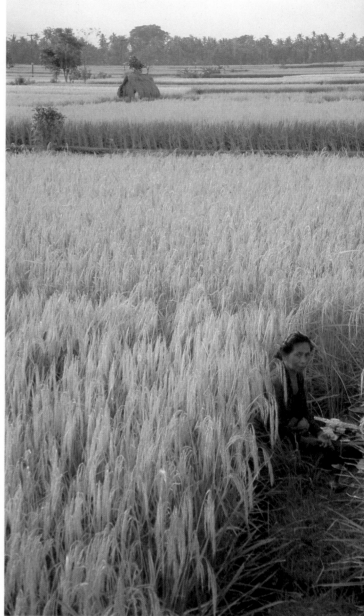

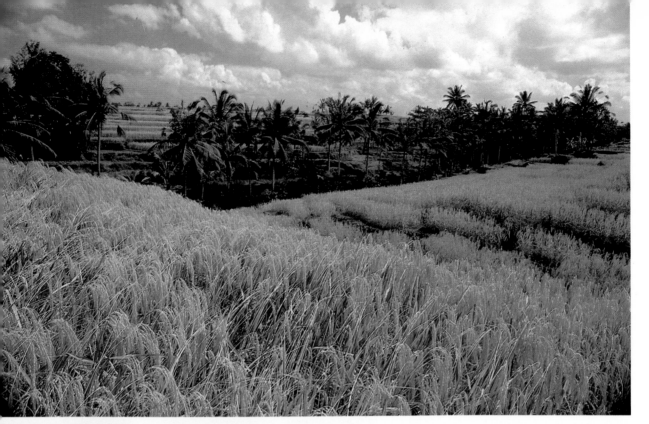

7. When the rice is ripe, the hillsides resemble a flowing golden-colored sea.

8 and 9. After the grain has been cut by hand with a sickle, the stalks are tied into bundles.

10. The rice is threshed by beating it with a wide bamboo pole until the grain has been separated from the stalks.

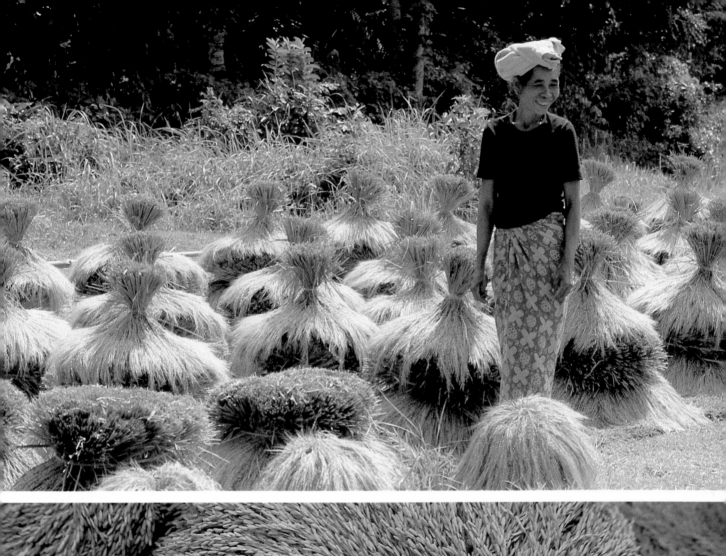
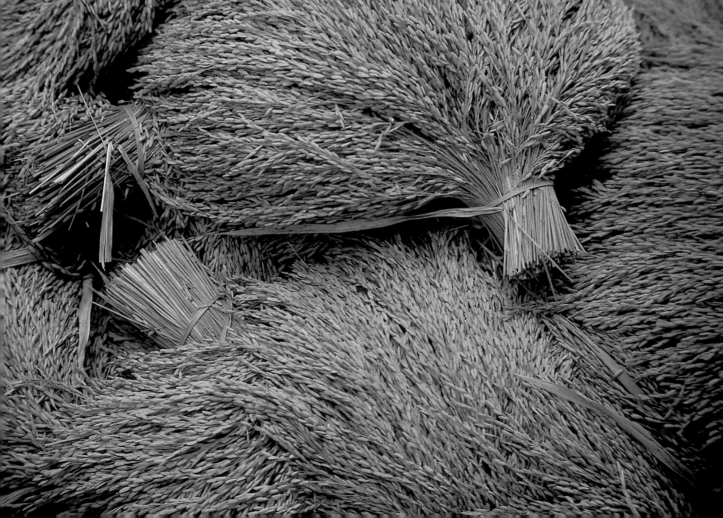

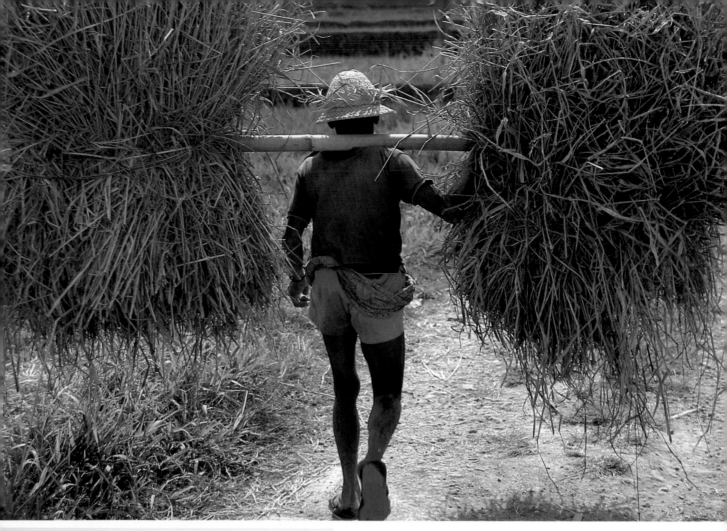

13. Detail of bamboo leaves.

11. The long dry grasses, tied at both ends of a bamboo pole, are carried from the field. The worker shades his head with a palm-leaf hat.

12. Bamboo, Japan. The nodes, which appear at regular intervals, lend a sense of scale to the bamboo plants, which are about forty feet tall.

14. Coconut palms, Bali, Indonesia. The graceful coconut palm provides food, drink, clothing, and shelter to the people of Bali.

15. Coconut-palm frond, Bali, Indonesia. This dry coconut-palm frond is rich in color and texture.

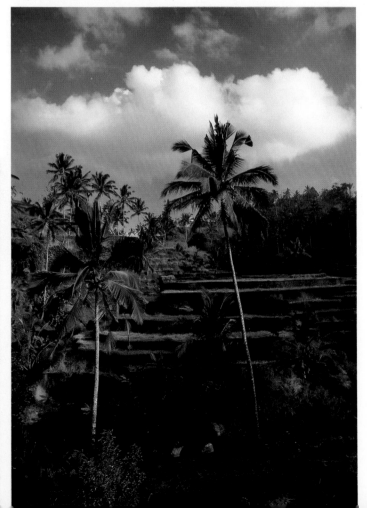

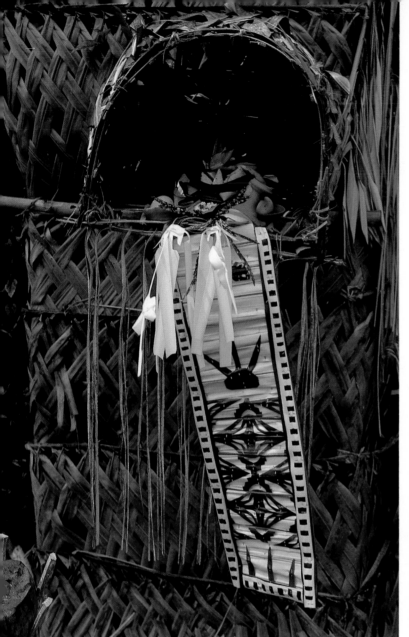

16. *Lamak* (altar hanging for offering rituals), Bali, Indonesia. The *lamak* is made from two kinds of leaves—dark green sugar palm and light yellow-green coconut palm. The dark leaves are pinned on to the light background with small pieces of the palm-leaf vein. An infinite variety of designs reflects a symbolism with local and personal variations.

17. *Canang buratwangi—lengawangi* (offerings for sacrificial days), Bali, Indonesia. Working together, the women make these special offerings. The bottom of the small baskets is made of banana leaves (as seen in the woman's hand); the sides are made of palm. Rice, fruits, and flowers, which will soon be placed in the offering, are within easy reach.

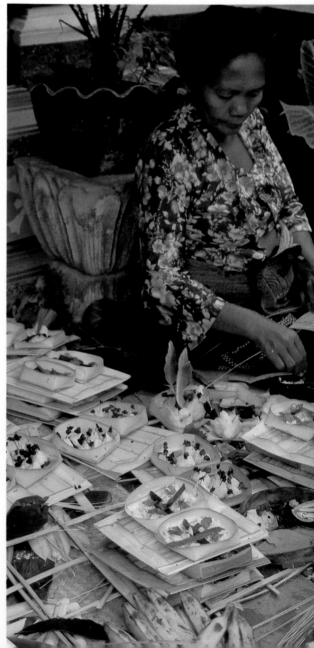

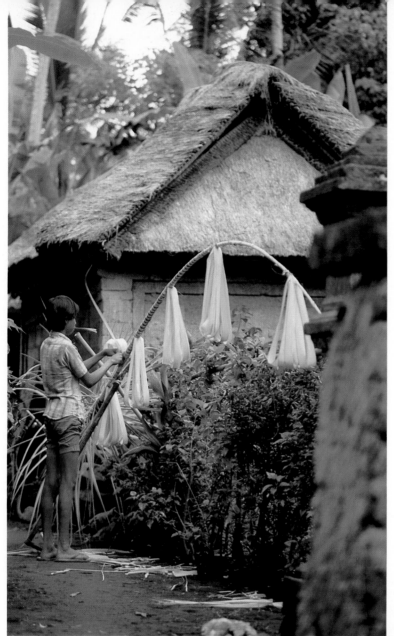

18. *Pènjor* (festival hanging), Ubud, Bali, Indonesia. During *Galungan* and *Kuningan*, the Balinese New Year's celebrations, the men of each family gather to make a *pènjor* of bamboo decorated with palm. The *pènjor* is a male symbol of fertility; in fact, the objects hung from it—rice, fruits, and cake—are even referred to as testicles. Photograph: Mary Hunt Kahlenberg.

19. *Pènjor* (festival hanging), Ubud, Bali, Indonesia. A tall bamboo pole (approximately 18′), the *pènjor* is elaborately decorated with fresh-cut palm leaves before it is set in front of the family compound. Photograph: Mary Hunt Kahlenberg.

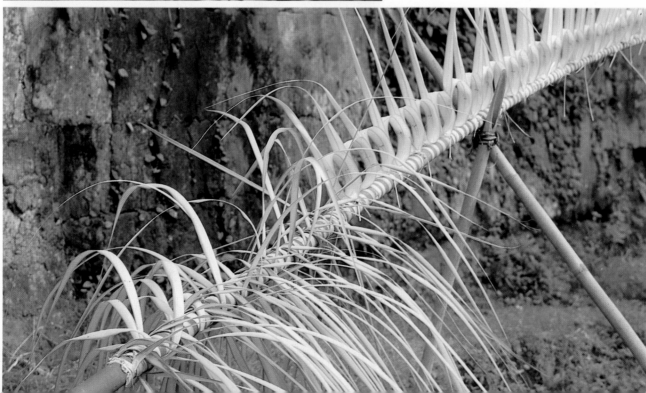

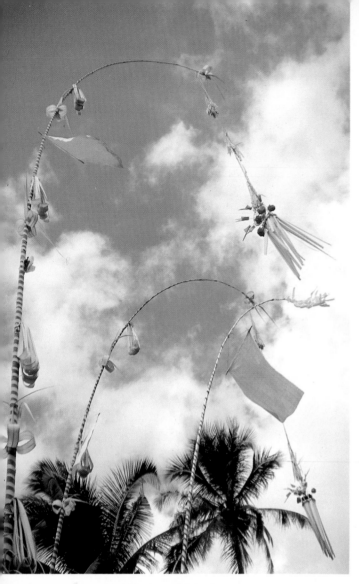

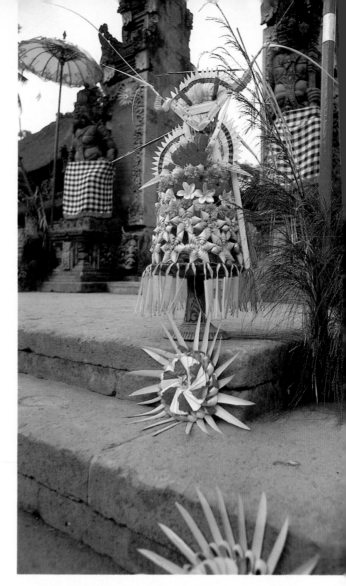

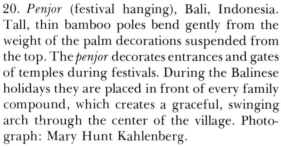

20. *Penjor* (festival hanging), Bali, Indonesia. Tall, thin bamboo poles bend gently from the weight of the palm decorations suspended from the top. The *penjor* decorates entrances and gates of temples during festivals. During the Balinese holidays they are placed in front of every family compound, which creates a graceful, swinging arch through the center of the village. Photograph: Mary Hunt Kahlenberg.

21. Temple offering, Bali, Indonesia. In preparation for a dance performance the temple gate is decorated with fresh palm offerings. To accent the green color of the palm bright red and orange flowers are set around the top.

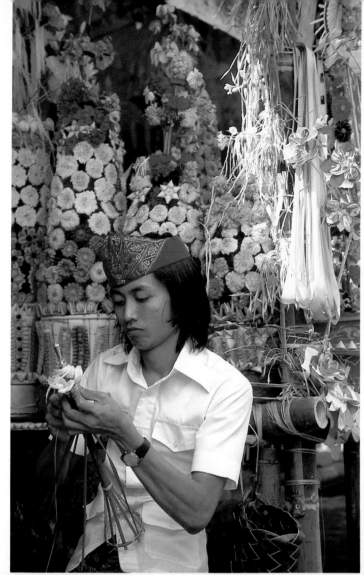

22 and 23. Ceremonial offerings, Bali, Indonesia. In preparation for a large ceremony impressive offerings called *gebogan* are made of palm, rice cakes, and flowers. The young man in ceremonial dress is constructing a smaller offering by attaching *cempaka* blossoms to a split-bamboo frame.

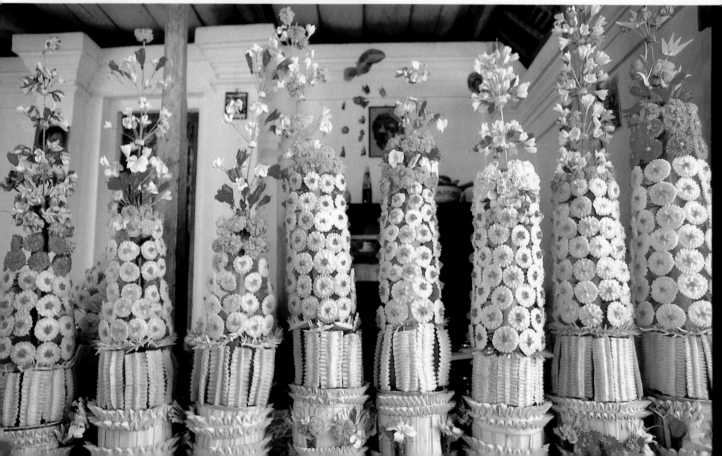

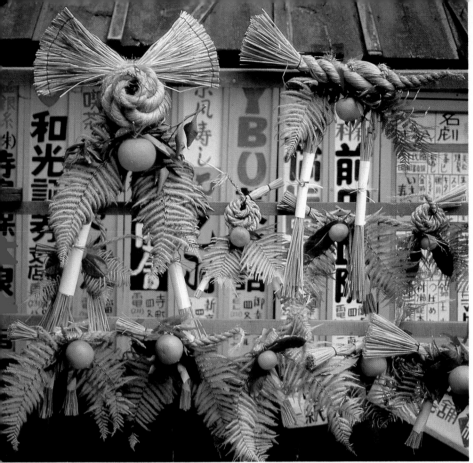

24. *Shimenawa* for sale, Kyoto, Japan. In larger markets *shimenawa* vendors set up stalls. Here *shimenawa* are hung in front of colorful signs. Tied to the *shimenawa* are an orange and two fern leaves. These objects are not directly symbolic; rather they suggest a play on words. The word for orange sounds like the word *dai-dai*, which means "from generation to generation"; hence it is used as a symbol for tradition. The fern *urashiro* (Gleicheniaceae) is green on one side and white on the other; this stands for honesty and sincerity. Its paired leaves also stand for happy and fruitful marriage.

25. New Year's offering, Kyoto, Japan. Certain Shinto shrines are associated with a particular type of business or trade and each produces a distinct style of New Year's offering. These wheel-shaped forms are from a shrine associated with craftsmen. The forms are hung in the workspaces all year and at New Year's they are returned to the shrine and burned as part of a ceremony. Then they are replaced with new and larger offerings, symbols of increased prosperity.

26. Decorative saké bottle stopper, Tokyo, Japan. These stoppers are used only for New Year's celebrations. They are made of split bamboo that is bent and tied to create a variety of shapes. Small pieces of gold foil and bright red paper add a festive quality.

27. Saké kegs, Kyoto, Japan. Gifts of saké kegs are made to Shinto shrines. The kegs, which hold approximately nineteen gallons each, are made of wood wrapped in a reed matting and bound with a straw rope. The calligraphy on the kegs is the mark of the distillery.

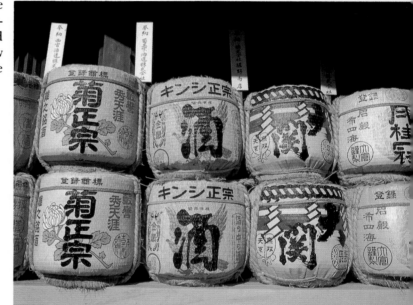

28. Offering baskets, Bali, Indonesia. Sitting in front of a twill-weave bamboo wall, this woman makes small baskets for the day's offerings. Stripping the spine from the palm leaves, she makes small pins that are used to hold the basket together.

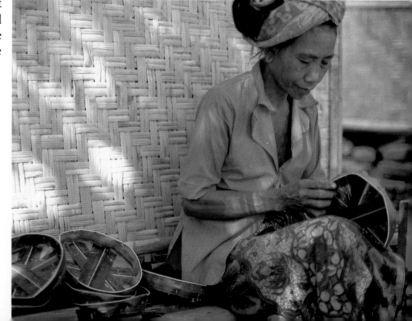

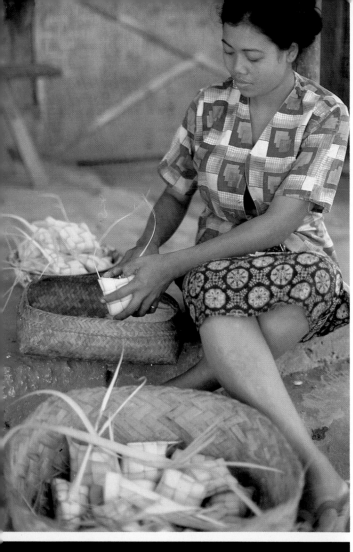

29. Rice-cooking packet, Bali, Indonesia. A Balinese woman plaits two strands of fresh palm to form this rectangular packet, which is then stuffed with rice, tied at the top, and submerged in a pot of boiling water. When the rice is cooked, the packet can be hung by its tied ends until needed. The Western world has copied this efficient Balinese technique, but one may argue that peas and carrots in a plastic bag lack the aesthetic qualities of this organic combination.

30. Food cover, Thailand. 12¼″ x 28½″. This cover is used to protect food from insects. The contrasting colors of the dyed palm utilize the geometric designs of the plaited technique to full advantage. Collection of William Shire.

31. Basket for flower arranging (detail), Japan. An example of the exquisite fluid quality of woven bamboo. The complete basket is illustrated in figure 52, page 40. Collection of the Field Museum of Natural History, Chicago.

32. Basket (detail), northern Sudan. This basket is made of grass coiled with brightly colored palm strips. The tightly woven geometric designs resemble rugs woven in the same area.

30

32

31

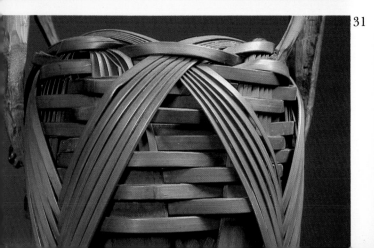

35. Stone laver with bamboo water ladle, Ohara Sanzen-in, Kyoto, Japan. A standard feature of a Japanese garden is the stone laver with bamboo ladle that serves practically and symbolically as the place where one cleanses both hands and soul. A bamboo waterfall keeps the contents of the bowl aerated and fresh, green lengths of bamboo support the ladle. The effect is beautifully refreshing.

34. Straw lace, Aargau, Switzerland. Small decorative appliqués made to adorn hats, these laces are between one and two and one half inches in size and were made from plaited rye. They are amazingly fine and quite realistic copies of flowers, leaves, and ears of rye. Collection of the Strohmuseum, Aargau, Switzerland.

33. Market day, Ghana. Wide, plaited palm-leaf hats provide protection for long hours in the sun. Photograph: Renie Conley.

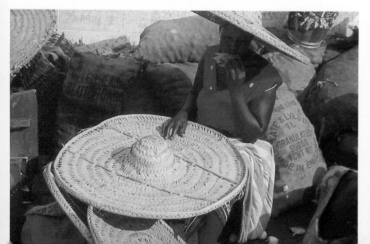

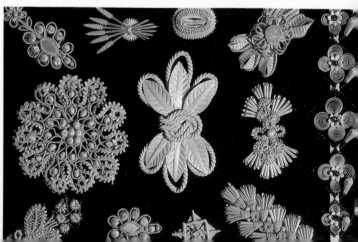

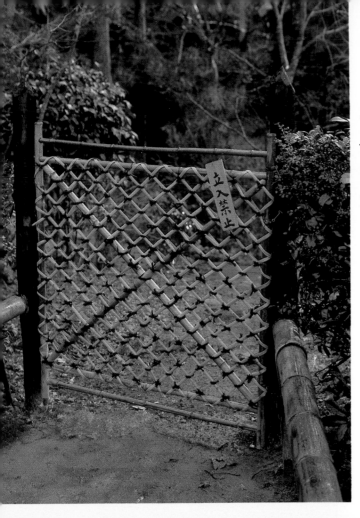

36. Gate in a garden fence, Jojuin Garden, Kiyomizu Temple, Kyoto, Japan. Two kinds of fence are used in Japanese gardens—partitions and screens. This partition defines an area without blocking the view beyond it. Split bamboo has been woven over a frame of fresh green bamboo and tied with black palm fiber. The light and dark tones combined with the luster of the bamboo lend elegance to this simple form.

37. Basketry sculpture, made by a student of Chikensai Azuma, Kyoto, Japan. 7″ x 15¾″. The basketmaker has effectively contrasted the symmetry of the two individual forms by placing them asymmetrically. The surfaces appear highly animated because of the varying width of the bamboo strips.

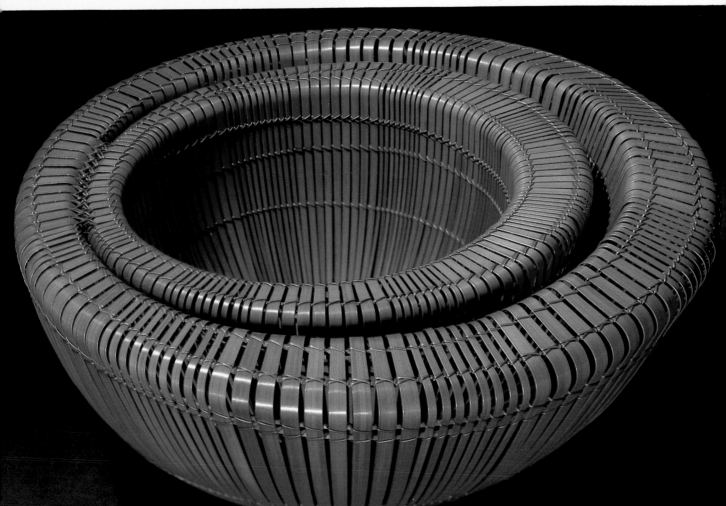

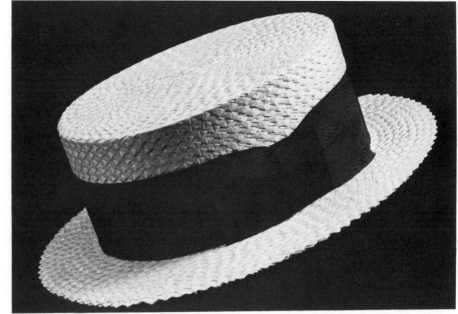

69. Man's straw boater, Luton, England. 3½″ x 11¾″. When we think of a straw hat, this is what most often comes to mind. Tipped at a jaunty angle, just such a hat must have looked very dapper when worn by a fashionable man in the 1920s. Collection of the Los Angeles County Museum of Art.

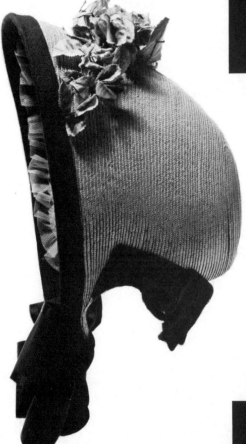

70. Poke bonnet, Aargau, Switzerland. 9″ x 11″. This demure bonnet for a lady of the 1840s is made of straw plaits sewn together into a graceful shape. Collection of the Los Angeles County Museum of Art.

71. Straw hat by Sally Victor, United States. 3¼″ x 13″. As part of the fancy of fashion, straw hats go in and out of style. This hat, designed in the late 1940s, uses a variety of plaits, which have been re-plaited together. The resulting texture looks almost like popcorn covered with melted butter. Collection of the Los Angeles County Museum of Art.

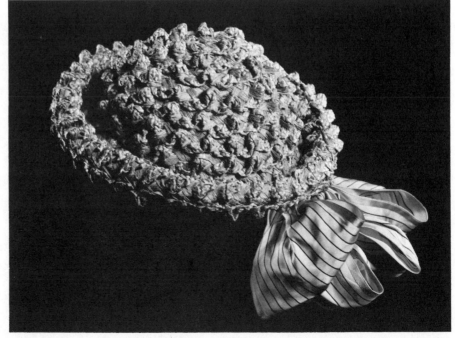

72. Man's hat, Tayabas, southern Luzon, Philippines. 5½″ x 12¼″ x 10¼″. The swirling diagonal design of alternating dark and light stripes with small checks on a gently sloping shape make this an exceptionally beautiful hat. Made of plaited bamboo in the lowland areas of southern Luzon, it has an inner crown to provide ventilation between the head and the hat. Men also use it for carrying small objects such as a pipe and tobacco. Collection of the Field Museum of Natural History, Chicago.

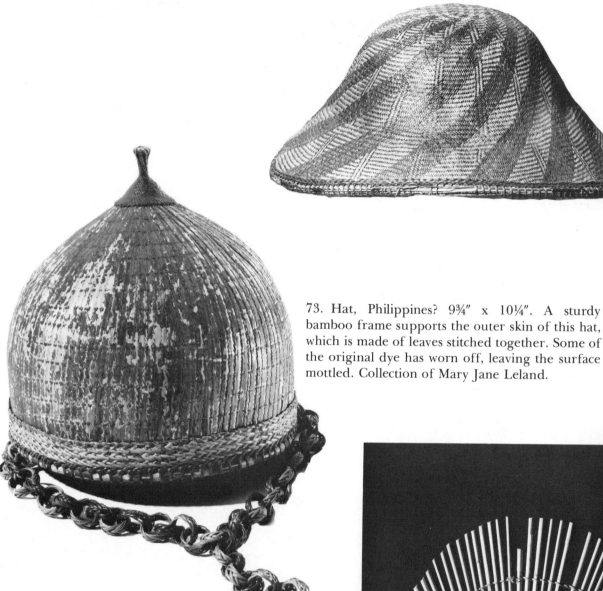

73. Hat, Philippines? 9¾″ x 10¼″. A sturdy bamboo frame supports the outer skin of this hat, which is made of leaves stitched together. Some of the original dye has worn off, leaving the surface mottled. Collection of Mary Jane Leland.

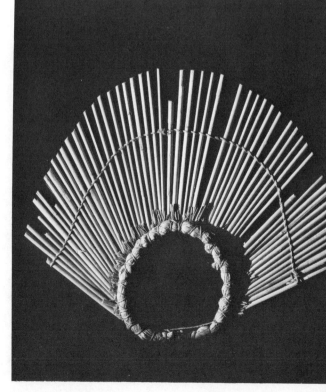

74. Sedge dance headdress, Hopi people, northern Arizona. 17½″ x 19″. This crown of rays simulating the sun was made to be worn by a kachina dance figure in Hopi celebrations. Collection of the Maxwell Museum of Anthropology, Albuquerque, New Mexico.

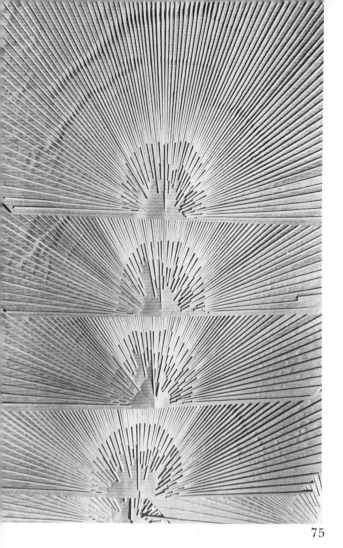

75

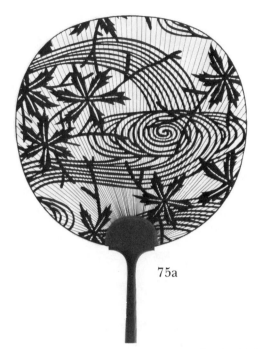

75a

75, 75a, 76. *Uchiwa*, Kyoto, Japan. *Uchiwa* are made of finely split bamboo. The ribs are lined up on a paper background. This is done using only the eye as a guide. The more skilled the craftsman, the closer he can place the ribs. The number of ribs composing the fan determines its quality. After the bamboo ribs have been arranged, decorative papers are pasted front and back, leaving only a suggestion of the ribs. Recently, a new style of fan has developed that shows this delicate ribbing. Instead of covering the ribs entirely with paper, a paper filigree is pasted on, making the fan somewhat open. In this example (76) the free form of the water-and-maple-leaf design is tempered by the straight structure of the bamboo ribs. See an enlarged detail of this fan illustrated in the frontispiece (page ii).

76

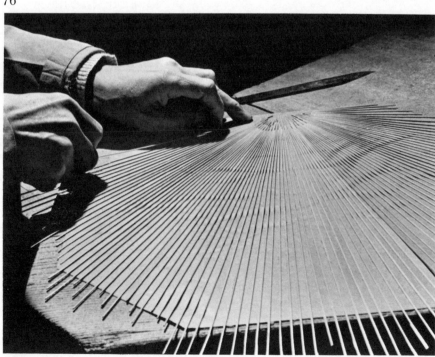

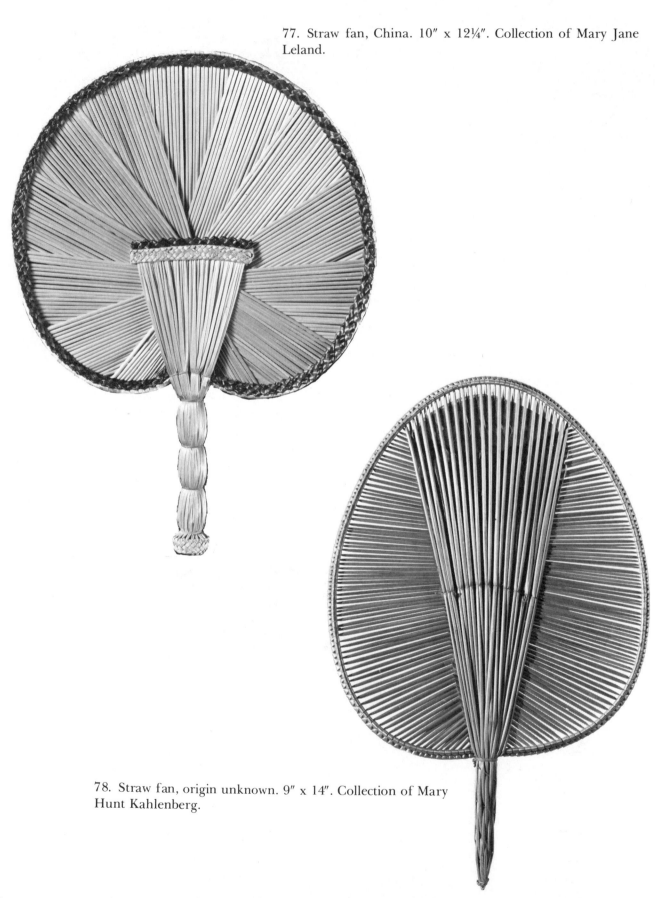

77. Straw fan, China. 10″ x 12¼″. Collection of Mary Jane Leland.

78. Straw fan, origin unknown. 9″ x 14″. Collection of Mary Hunt Kahlenberg.

79. Straw fan, Spain. 10″ x 14″. Before air conditioning, using a fan was essential for comfort on hot days. Fans were made wherever the climate demanded them and in some areas they were also a trade item. No matter where they were made, all fans were similar in construction. The stiff quality of the straw used made the fan rigid but did not lend itself to being twisted and bent to any great extent, so most of the decorative characteristics were achieved by varying the angle of the straw. The play of light across the straw adds delicacy to pieces that are already almost weightless. Collection of Brigna Kuoni.

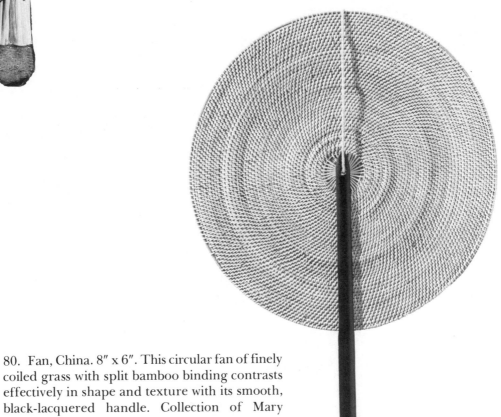

80. Fan, China. 8″ x 6″. This circular fan of finely coiled grass with split bamboo binding contrasts effectively in shape and texture with its smooth, black-lacquered handle. Collection of Mary Hunt Kahlenberg.

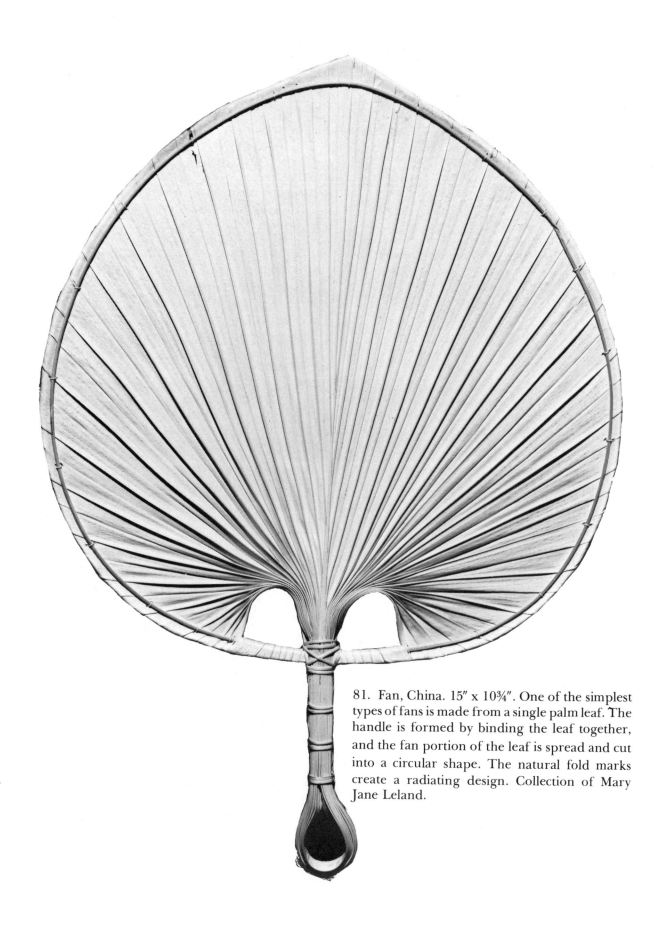

81. Fan, China. 15″ x 10¾″. One of the simplest types of fans is made from a single palm leaf. The handle is formed by binding the leaf together, and the fan portion of the leaf is spread and cut into a circular shape. The natural fold marks create a radiating design. Collection of Mary Jane Leland.

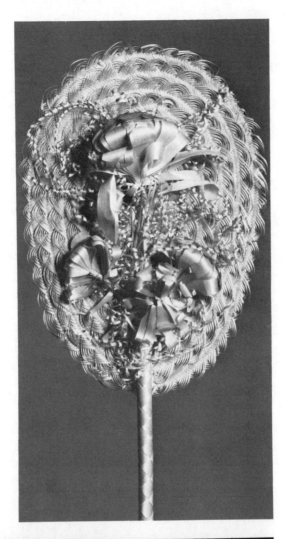

82. Fan, probably China. 11¾″ x 7⅛″. An extremely fine fan made to satisfy elaborate Victorian tastes. The background is made of plaited loops, which is topped with curled pieces of straw that simulate flowers. Collection of The Oakland Museum, California.

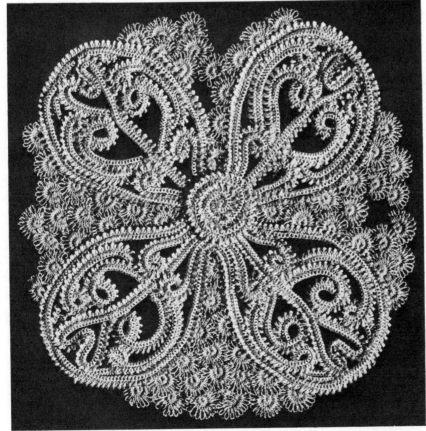

83. Rye-straw lace, Aargau Canton, Switzerland. Diam. 10¼″. In Switzerland rye was grown specifically to make straw hats and decorations. As white straw was favored, considerable effort was made to keep it light in color. The straw was sown close together, cut when unripe, and subsequently bleached in the sun. A rye straw is split into fine splints, then passed through a mangle to make it more pliable. The plaiting was usually done at home during the winter months. Individual skill and imagination accounted for the wide variety of intricate plaits. Collection of the Strohmuseum, Aargau, Switzerland.

84. Bamboo vest, China. 22½″ x 19½″. Bamboo vests are used in China and Japan as a type of thermal underwear. They provide insulation in winter and allow cool air to circulate next to the skin in summer. Short pieces of slender bamboo stem are threaded like beadwork and netted into a mesh with a knot at each corner. This example is of particularly fine quality and has a border of intricate netting at the bottom. Collection of the Los Angeles County Museum of Art.

85. Apron, Hupa Indians, 19th century, northern California. 27″ x 14″. Fashioned from plaited grass stems strung together with pine nuts, the apron makes a marvelous rustling sound when it moves. Collection of the Southwest Museum, Los Angeles.

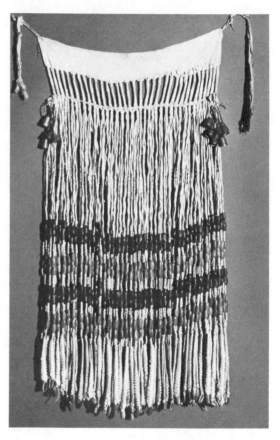

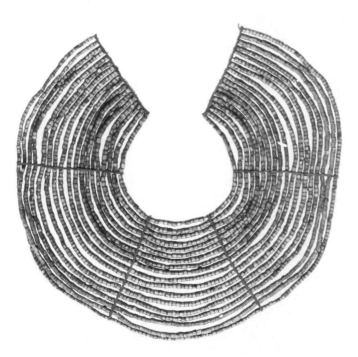

86. Necklace, Nubia, Sudan. Diam. 13¼″. The allure of gold is deeply rooted in mankind. The gold ornaments that attracted the admiration of pharaohs of ancient Egypt still attract thousands to museum galleries. Alchemists worked for centuries to transmute base metals into gold and failed, but common people found a substitute. They turned straw into gold by featuring its golden polished surface. For this Nubian necklace hollow straw sections were filled with wax to make beads, which were then strung together at six points with a leather brace. The effect is a glittering necklace in a style originated in the pharaonic period. Collection of John Brouse.

Tools and Utensils

A straw broom, a reed brush, a bamboo rake: in every household a few simple items are used on a daily basis. With months or years of service they gain a patina of stains and marks, becoming old friends. Eventually they wear out. They may remain around because of a respect and fondness for their essential qualities but, finally, new utensils replace them. We become fond of these simple objects because they perform tasks to our satisfaction, and their utility has been proven through centuries of use.

Man's earliest tools were invented because of his survival needs: clubs for hunting, pointed bamboo spears for fishing, containers such as a plaited palm leaf basket for gathering wild grains and berries. Agriculture spurred the next stage in the development of tools. Simple implements were devised to turn the soil, to dig holes for planting, and to cut ripe fruit. Simultaneously, domestic utensils were conceived: pots, strainers, and a variety of brooms and brushes.

Until the Industrial Revolution much of the world's population was self-sufficient. With relative simplicity, the land directly provided almost everything—food, clothing, shelter, furnishings, tools, and utensils. Objects were usually made for use within the family, assuring a certain level of pride in workmanship. Goods and services were bartered, not paid for. There were some skilled craftsmen who supplied tools for the community, to them, learning a craft was part of their birthright and craft skills were passed from one generation to the next.

The Industrial Revolution brought two significant changes: power machinery and an economy based on money rather than goods. Manufacturing equipment produced wares from wood and metals; the use of plant materials such as grass and palm began to diminish because they were too fragile to be worked by machine. No longer commercially viable, the handcrafted object also began to vanish. Craftsmen became anonymous machine operators, and centuries of tradition began to disappear.

Today, there are a few areas still producing wares from natural materials, either because they are so inaccessible that there was no attempt made to industrialize them or because they have remained psychologically isolated from machine power. In Japan, for instance, tradition remains important. As new ideas penetrate daily life, the perpetuation of ancient traditions becomes even more valuable.

The Japanese tea ceremony is an ancient custom that utilizes the highest levels of traditional Japanese craftsmanship. Tea-ceremony utensils have their origins in everyday needs but they have been refined through centuries of ceremonial use. This does not mean that items have simply been decorated, rather, they have been intentionally simplified in a conscious effort to keep this form of expression—the tea ceremony—in harmony with natural forms.

In most countries, however, the aesthetic qualities of tools and utensils are not usually a concern. Functional objects are produced, with modifications and improvements taking place at a barely visible rate. Few changes occur in the basic design, although occasionally changes are made in decorative styles. Because use is naturally destructive, worn tools and utensils eventually must be replaced. This marks the passage of time; centuries of repetition of a particular design provide a link with the past and even though such tools and utensils may become outmoded, we continue to admire them for their simplicity of concept and graceful lines.

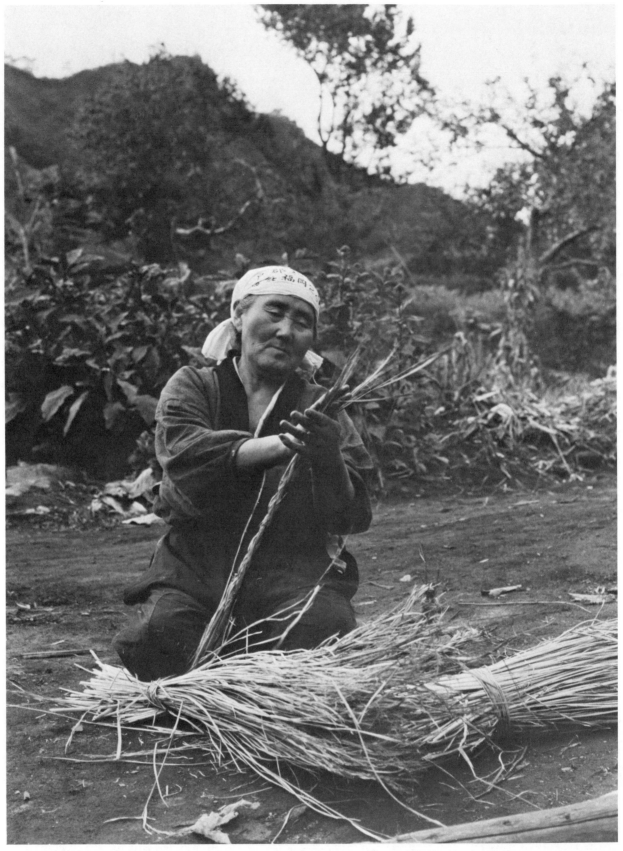

87. Making a straw rope, Torigoe, Ichinohe-cho, Ninohe-gun, Iwate Prefecture, Japan. Items sold at market are tied with coarse rope made from beaten rice straw. Photograph: Kazuyoshi Kudo.

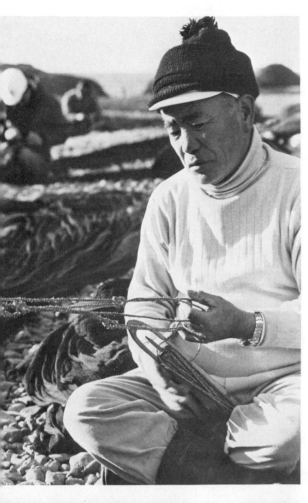

88. Fishnet, Uchiura Bay, Japan. On winter afternoons fishermen gather to repair their nets or to make new ones. Nylon is used for nets today, but a few men still remember how the old nets were woven from grass that grows in southern Japan. Using a shuttle with a length of grass rope wound around it, this fisherman makes a net by forming loops and securing them with slipknots. When the net is completed, it is left to soak in cold brine. The outer portion of the thread rots away and the inner portion shrinks, making the net very strong. Such a net was once used for catching tuna fish.

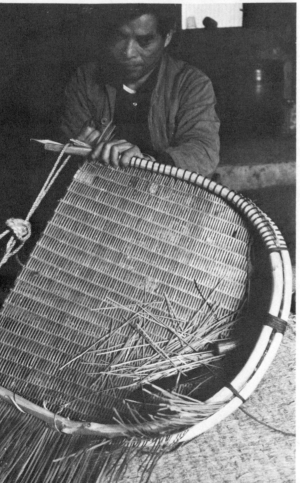

89. Winnowing basket, Kakinotani, Hitoyoshi-cho, Hioki-gun, Kagoshima Prefecture, Japan. 22½" x 24⅜". This winnowing basket is made of bamboo and wild cherry tree bark. The wood is bent into a horseshoe shape, and the bamboo is woven in an open mesh, allowing air to pass through as the basket is tossed in the winnowing process. Photograph: Kazuyoshi Kudo.

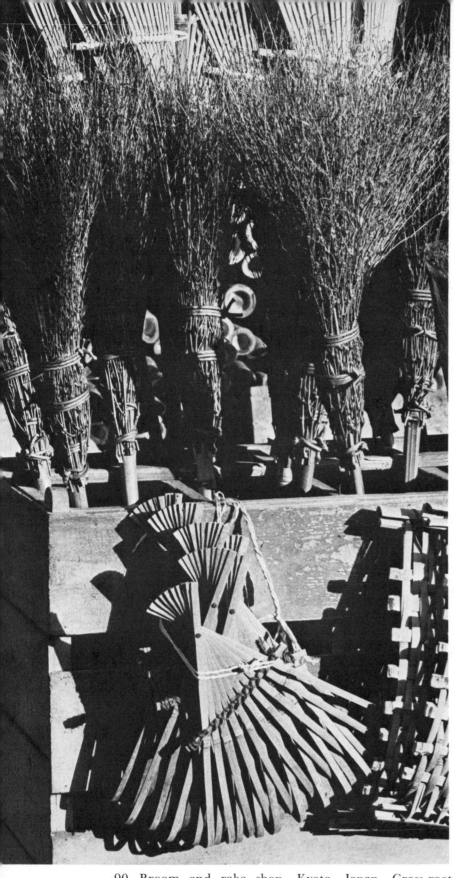

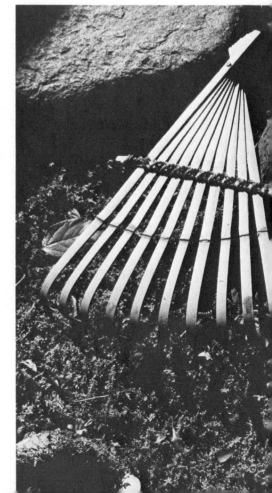

91. Hand rake, Kyoto, Japan. 6″ x 12″. A small hand rake, required for the meticulous attention given to a Japanese garden, utilizes several important aspects of bamboo. For example, the tips of the rake have been heated and bent so that they hold their shape permanently. The flexibility and strength of bamboo provide the needed resilience to gather leaves.

90. Broom and rake shop, Kyoto, Japan. Grass-root brooms and bamboo hand rakes are gardeners' tools that have been unchanged for centuries. Their rugged flexibility remains unsurpassed by today's modern materials.

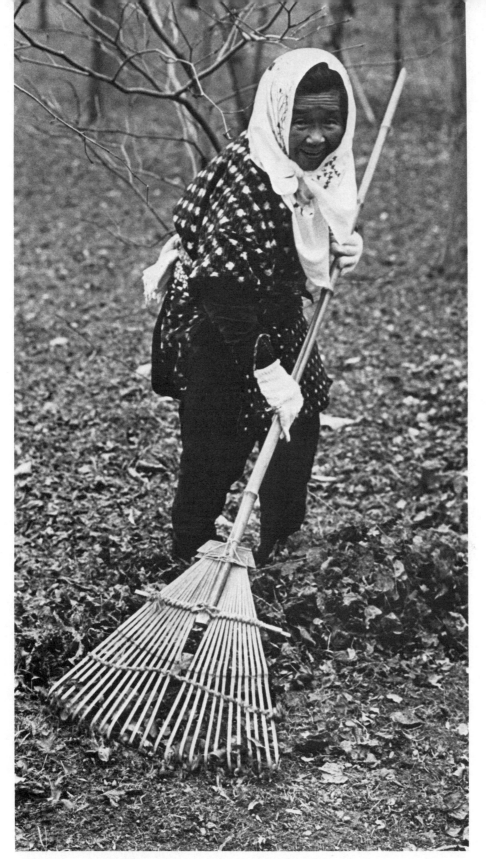

92. Japanese gardener, Kyoto, Japan. For centuries women have worked in Japanese gardens wearing the same traditional costumes and using the same traditional tools. There is nothing unusual about this simple and efficient bamboo rake; variations of it are used all over the world. A length of bamboo serves as the handle; the rake itself is made from split bamboo fastened to the handle, then spread and laced to a bamboo strip; and the ends are heated and curved. Perhaps the familiar rake may become a tool of the past as more and more of today's gardeners gather leaves with gasoline-powered blowers strapped to their backs.

93

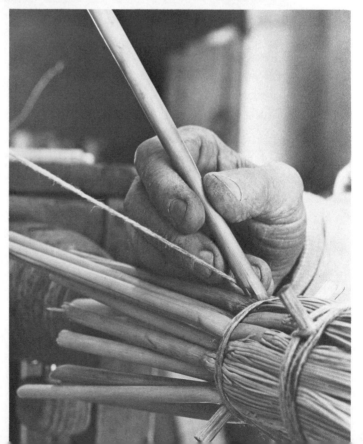

93b

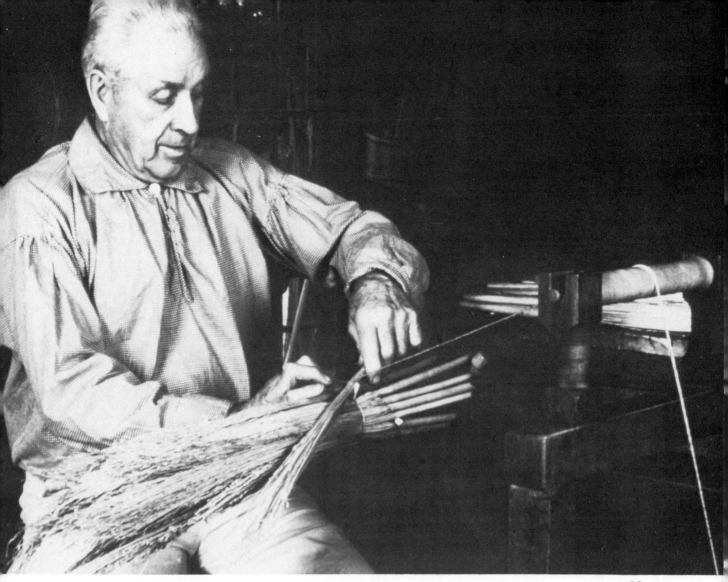

93, 93a, 93b. Broom construction, Old Sturbridge Village, Massachusetts. Sturbridge Village re-creates rural New England life from 1790 to 1840. This early nineteenth-century broom-making machine binds the roots of broom corn, then twists them around a wooden handle to make a broom. Photograph: J. Alan Brzys. Old Sturbridge Village Photographs.

94. Whisk broom, Japan. 13½″ x 6¾″. This graceful whisk broom is made of rice straw; the handle is plaited with cotton thread. Collection of Mary Hunt Kahlenberg.

95. House brush, Korea. 18″ x 8″. The brush may have been one of man's earliest utensils. A simple clump of grass roots serves the purpose, but this brush is a beautifully conceived object. Here the roots have been tied together firmly with wire in several places. Unbound ends fan out from the handle to form the brush.

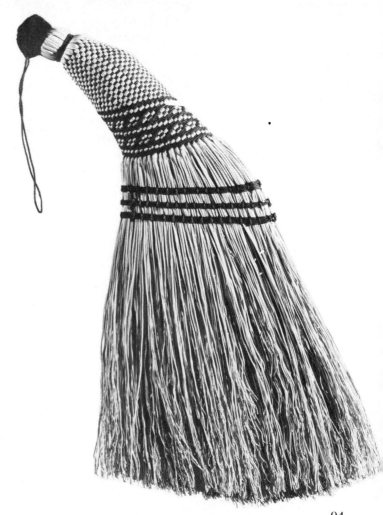

94

95

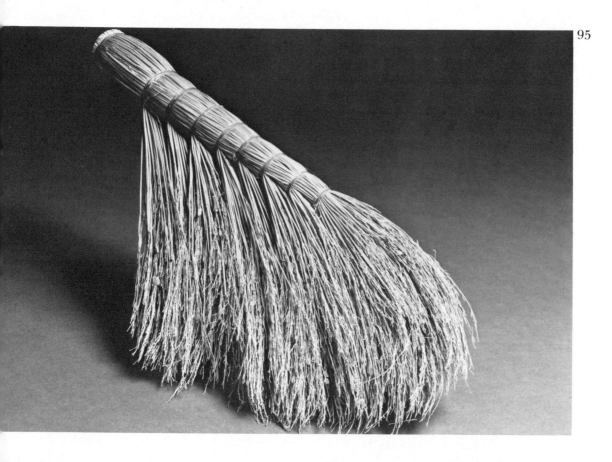

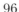
96

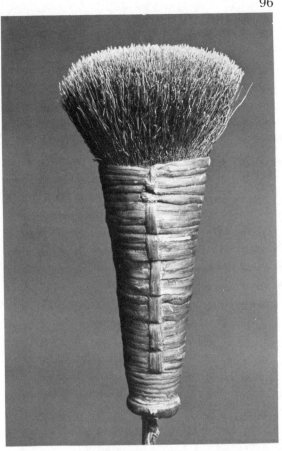

96. Napping brush, Korea. 9½″ x 4¾″. A large handful of grass roots was bound together with cane to make this brush. As an object, this brush has a particularly beautiful shape and texture. It was used to make a nap on woven fabric. Collection of Tom Fender.

97. Duck decoy, Paiute people, Nevada. 6½″ x 12″ x 6″. Making decoys from tule reeds is a tradition with the Paiutes. Bundles are twined together to form a lightweight body. The head and neck are separate and mounted on a stick that is poked through the tule into the body. The tule is both shiny and light enough to float. From a distance the decoy looks very much like a live duck. Collection of the Nevada State Museum, Carson City.

97

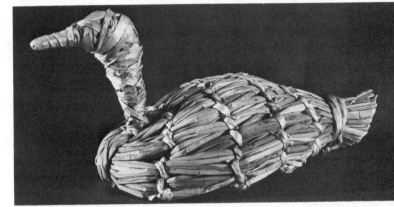

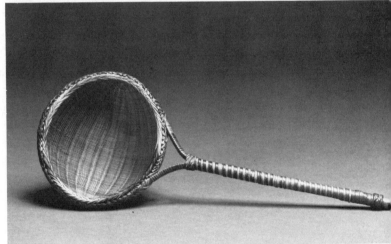

99

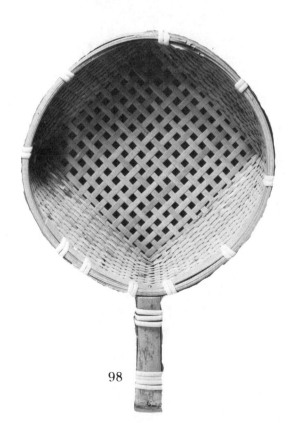

98

98. Strainer, Tottori, Tottori Prefecture, Japan. 7½″ x 2″. Woven from long, jointed bamboo, this strainer is used for washing vegetables. As is typical of rigid-plaited baskets, the form starts as a square shape and evolves into a circular rim.

99. Strainer, Philippines. 15½″ x 6″ x 2¾″. The bowl of this strainer is woven with a wickerwork technique and the rim is plaited. The contrast between the dark bamboo and the light rattan palm adds richness to this useful object.

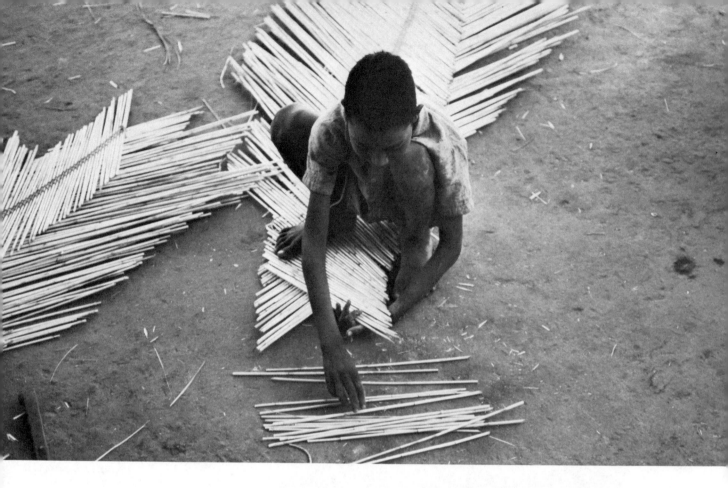

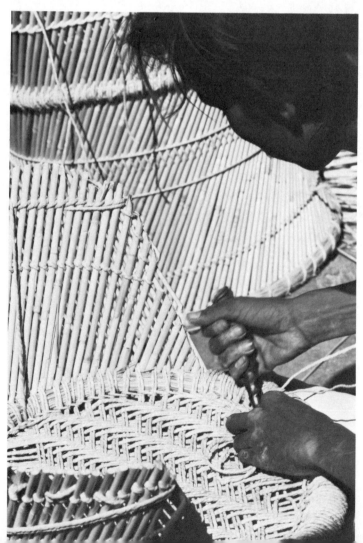

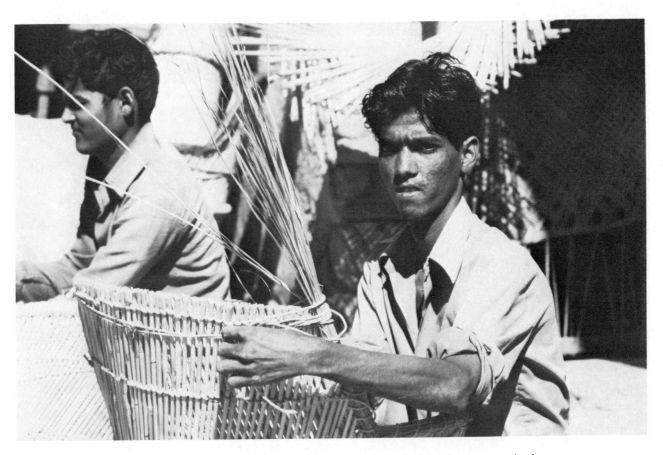

100, 100a, 100b. Chair construction, Ajmer, Rajasthan, India. Three stages in the construction of a chair. First, sections of dried sedge are laid out on the diagonal and twined together. This portion becomes the bottom and back of the chair. (The reason the sedge is arranged on the diagonal is that the individual stems are not sturdy but by wrapping them around the chair, they can share the load.) Second, a straw rope is woven for the seat with the use of a hook. Third, bundles of grass are wrapped around the edge to cover the ends and add support to the seat. Photographs: Donald R. Bierlich.

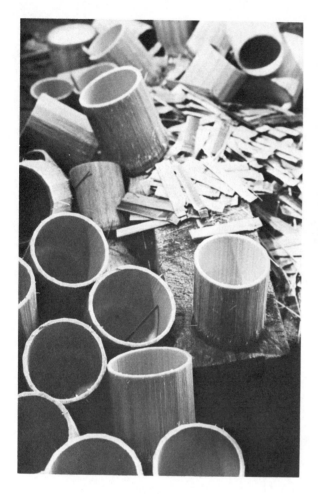

101, 101a. Preparation for making a *hishaku* (water dipper), workshop of Michihito Matsui, Kyoto, Japan. To begin the making of the bowl of a water dipper used in the Japanese tea ceremony, a length of bamboo is sawed so that a node serves as the bottom. The outer skin of the bamboo is removed with a sharp knife and the bowl is boiled, shrinking considerably in the process. The bowl is dried naturally, then reboiled, returning almost to its original size. This preshrinking prevents the bowl from cracking when it is dipped into hot water during the tea ceremony.

103. New Year's flower vases, by Michihito Matsui, Kyoto, Japan. Approx. 10″. For the Japanese New Year's celebration tea-ceremony utensils and flower vases are made from green bamboo. Matsui makes these wall vases by cutting one V-shaped hole for the flowers and a smaller hole in the back so that the vase can be hung on the wall. In this picture he is about to polish the bamboo with a brush made from a tightly bound bundle of grass. The green color of the bamboo is particularly pleasing in the context of a cold and dark Japanese winter.

102. *Hishaku* (water dipper), Kyoto, Japan. Bowl: 2″ x 2⅛″; handle: 13⅝″ x ¼″ x ¼″. The *hishaku*, used to ladle out hot and cold water in the preparation of utensils and the making of tea, is one of the most important utensils of the Japanese tea ceremony. Because the handle is more than a foot long and a quarter-inch wide, considerable skill is needed to pour gracefully. Collection of Mark Schwartz.

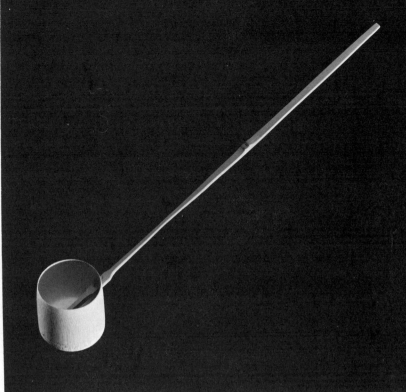

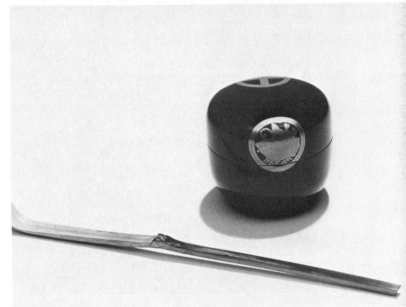

104. *Chashaku* (tea scoop) and tea caddy of lacquered bamboo, Japan. Scoop: 7¼″ x 14″; caddy: 3½″ x 3¼″. The slightly curved bamboo scoop is used for measuring out powdered tea in the Japanese tea ceremony. The grain and color of the bamboo, the placement of the node, and the proportions of the scoop are all important aesthetic decisions made by the Japanese craftsman. The tea caddy is made out of two sections of bamboo; one is shaped into a thin-walled container, the other becomes a close-fitting lid. Although a relatively simple object, a great deal of expertise and sensitivity are required to craft its smooth curves and highly polished lacquer finish. Collection of Anita Brandow.

105. *Chasen* (tea whisk), Kyoto, Japan. 8½". The tea whisk, a Japanese tea-ceremony utensil, is swirled with the same motion used to beat an egg. Different teas call for different qualities of whisks: the best teas call for whisks with many spines. The technique of splitting the bamboo is similar to working with bamboo for less refined purposes but here the process is taken to extremes. A fine *chasen* can have as many as 120 spines. Collection of Mary Hunt Kahlenberg.

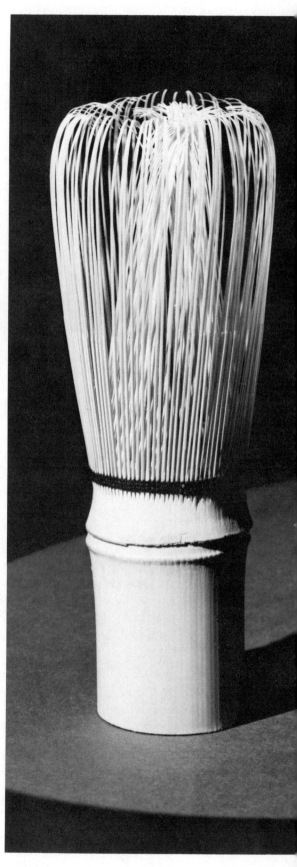

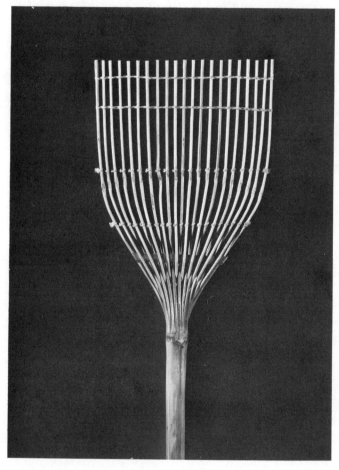

106. Rake (detail), Philippines. 68¼" x 12¾". Rattan is used in the same manner as bamboo to make this stiff rake. The end of the rattan is split and shaped by lashing the end across a bamboo strip. Collection of Vivian Burns.

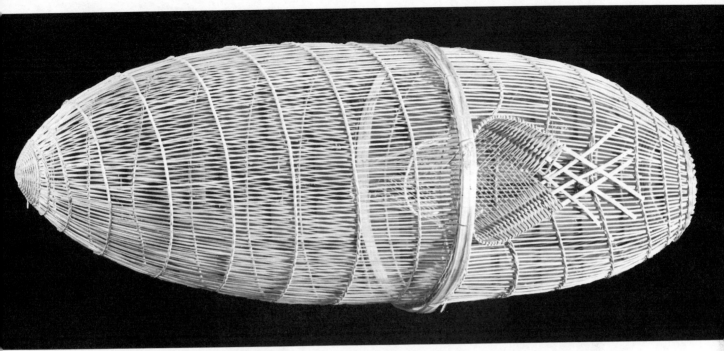

107. Fish trap, Nakhon Pathom, Thailand. 32″ x
8″. This trap is a capsule-shaped cage with a nar-
row opening on one side. Seeking the bait that
has been placed inside, a fish squeezes past sharp
fingers of bamboo that are angled to form a
passageway. Once inside the trap, the bamboo
fingers spring closed. The open weave keeps the
fish alive and fresh until the fisherman arrives to
untie the two halves of the trap.

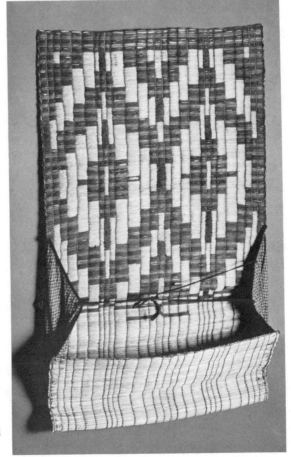

108. Hanging mat with pocket, Ainu people, Ja-
pan. 33″ x 25¼″ x 13½″. This sedge mat, with a
pocket to hold small objects, serves as a wall cov-
ering. The bold design is typical of Ainu decora-
tion. Collection of the Field Museum of Natural
History, Chicago.

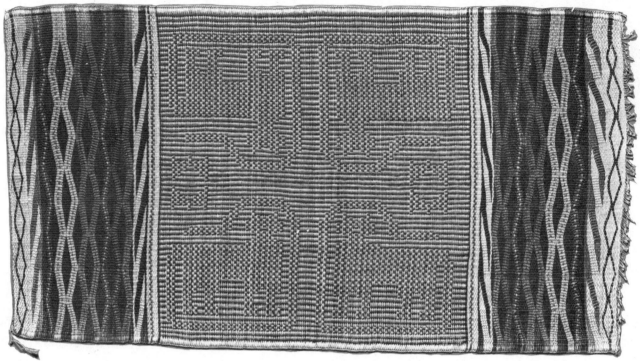

109. Mat, Sauk and Fox peoples, Oklahoma. 69″ x 37½″. The Sauk and Fox peoples were Algonquian-speaking tribes who lived in central Wisconsin. They wove these mats of grass and cotton. Although few mats remain today, the sophistication of this piece points to a highly developed mat tradition. The central design is of four panthers with encircling tails, which are subtly woven into the striped background (the panthers represent a group of mystical underwater felines). Collection of the Field Museum of Natural History, Chicago.

110. Knife and sheath, Ching dynasty (1644–1912), southern China. 9¾″ x ¾″. Elaborate fruit designs reflect the highly decorative Chinese carving of the bamboo knife handle and sheath. The relief is polished, accentuating the delicacy of the workmanship. Collection of David Kamansky.

111. Bamboo extension chair, Canton, China, 1802–1811. 37½″ x 26″ x 54½″.
When the Prince Regent (later George IV) furnished the Brighton Pavilion in
England with Chinese bamboo furniture, its vogue in the West was assured.
Chairs, settees, and tables were made in China for export to Europe and America.
Although these pieces were constructed in traditional Western furniture shapes,
the use of bamboo lent an exotic flavor. This extension chair was made with a
combination of bamboo and cane. The seat and extender are made of bamboo
slats painted with a Chinese decoration in black, and small pieces of bamboo
branches are used for the decorative elements. Despite the delicate and open
bamboo work, the scale of the chair appears large. Collection of the Rhode Island
Historical Society, Providence.

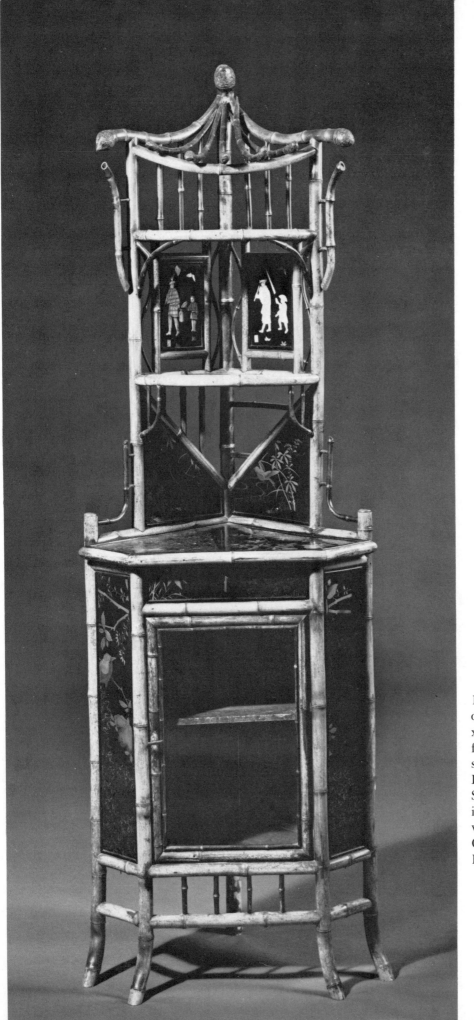

112. Bamboo étagère with lacquer panels, English, c. 1870. 74" x 38". Most Western bamboo furniture made in the "Oriental style" was manufactured in London between 1870 and 1930. Such pieces have the exotic feeling of the Orient and the serviceability of Western furniture. Collection of Raymond and Keith Antiques.

Architecture

The reed hut pictured on a seal dated around 3000 B.C. is our earliest visual record of a building.[4] Although the ancient reed huts have long since disintegrated, the hut form has endured for centuries. Today, the peoples of northern Nigeria and the Arabs in the Euphrates delta continue to construct these simple vernacular buildings. Architectural scholarship and criticism have focused on the monumental architecture of kings and queens, presidents and politicians, which are traditionally transformed every decade in accordance with the current vogue. Only in recent years has the common and ephemeral hut earned appreciation.

Grasses, reeds, palm, and bamboo are the local building materials in most areas of the world. Bamboo, which grows rapidly in comparison to wood, is inexpensive and readily available in tropical and semitropical climates.

The strength of bamboo—the multiple nodes reinforce it against collapse—makes it ideal for the structural supports of a building. Individual bamboo poles are relatively small, lightweight, and easy to transport and can be lashed together quickly (figs. 113a, 113b, 113c) or joined with more conventional carpentry techniques; split bamboo can be woven to make a wall. Although bamboo is quick to rot in tropical humidity, the simplicity of bamboo architecture allows the poles to be easily replaced.

Thatched roofs, found in both Europe and Asia, are made from a large variety of grasses, including broom, marram grass, oat, barley, rye, wheat, or rice straws, and tall sedges (not actually a grass but closely related). There are many ways to make thatched roofs but most are a variation of two basic methods. The first is to make individual lengths of thatch, folding bunches of grass around bamboo poles or wooden battens. The grass is tied in place by a palm or grass cord (figs. 113d, 114, 114a). The lengths are then transported to the site and laced or nailed to the rafters. The second method is to place the thatch in layers on the rafters. The thatch is held in place by heavy boards laid across it, or a web of rope weighted with rocks (figs. 120, 120a, 122). Whatever the method, the pitch of a thatched roof must be steep enough so that rain runs off before working its way through the layers.

Although less refined than roofs made of grass, thatched roofs may also be made of palm by tying layers of plaited palm branches to the rafters. A thatched roof of plaited palm branches is coarse in texture. Occasionally a portion of the leaves is dyed, emphasizing the pattern of the plaited technique. Palm is worked while green and pliable (figs. 129 and 130). As it dries, it shrinks and becomes brittle, so palm is generally used for temporary structures.

Thatched-roof buildings are made with local vegetation and simple skills, and held together with simple lashing. A Westerner is usually surprised to see that the method of construction is almost entirely exposed in the completed building. The structural elements are not hidden behind stucco, lath, tar paper, plaster, and paint. Cultures that build vernacular types of architecture utilize the labor of people who have grown up aware of exposed structure. Thus, construction techniques have become almost instinctive. Craftsmen now specialize in building such roofs, but traditionally this was a cooperative task. In Europe the men of a village would combine efforts to thatch a roof; in Asia women were also part of the work crew. With tasks corresponding to various levels of skills and experience, everyone could participate. This built a strong sense of community.

Throughout the world construction methods are determined by the availability of building materials and labor skills. Dwellings within comparable geographic and cultural areas tend to be similar, although distinct forms influenced by

religious dictates and social customs have been developed and refined over the ages. Social attitudes determine the size and layout of a building. The climate of an area determines the degree of weather resistance, insulation, and ventilation needed.

Although simple forms of shelter have been reproduced for thousands of years, they are gradually yielding to the buildings of industrialized societies—no matter how impractical these buildings may be.

Poured-concrete or cinder-block walls do not provide ventilation as do walls of woven bamboo or palm. Sheet metal, the modern replacement for a thatched roof, does not insulate or ventilate with the same efficiency as woven grass or palm, but this new and sadly less practical material is nevertheless regarded as a sign of progress, status, and wealth.

113. Corn Palace, Mitchell, South Dakota. The Corn Palace was conceived in 1892 as a "gathering place where city residents and their rural neighbors could enjoy a fall festival and a final fling before the long chill sets in." The outside of the building is decorated every year with naturally colored corn. The color range includes red, purple, yellow, white, and calico corn. After a theme for the festival is chosen, panels are designed and painted, then attached to roofing paper. Individual ears of corn are sawed in half lengthwise with a power saw and nailed flat side down to the panel. The work is completed just before the beginning of the festival so that the grain colors are bright and fresh. The Corn Palace festivities are a vestige of the ancient harvest celebration.

Balinese house-construction techniques, Bali, Indonesia.

114. Thin strips to be used for lashing are cut from bamboo.

114a. The strips are quickly tied around wide bamboo supports.

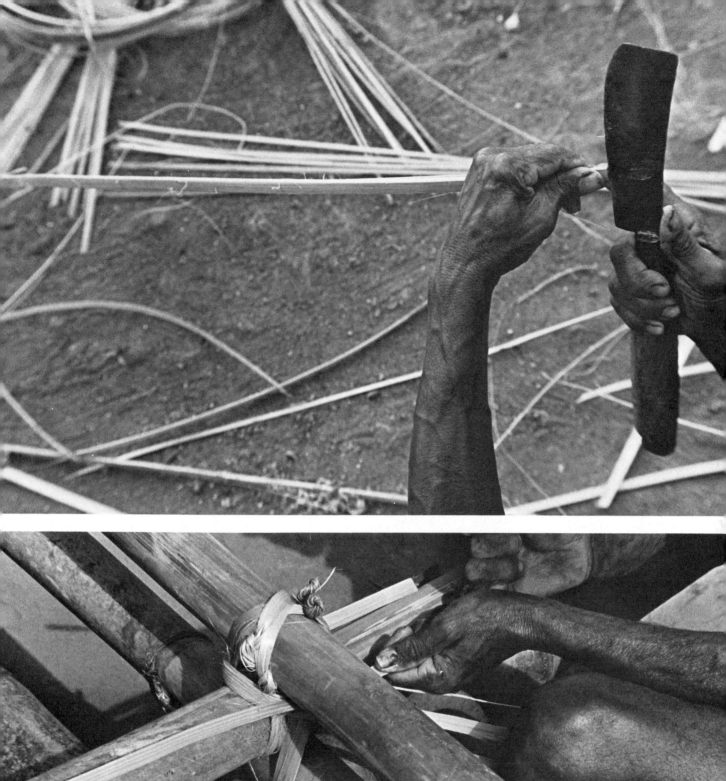
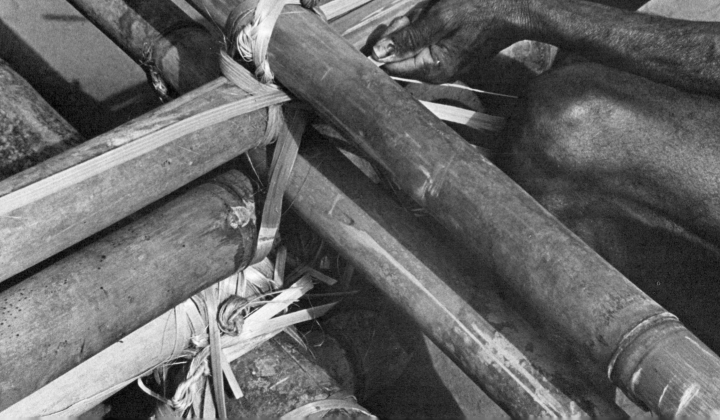

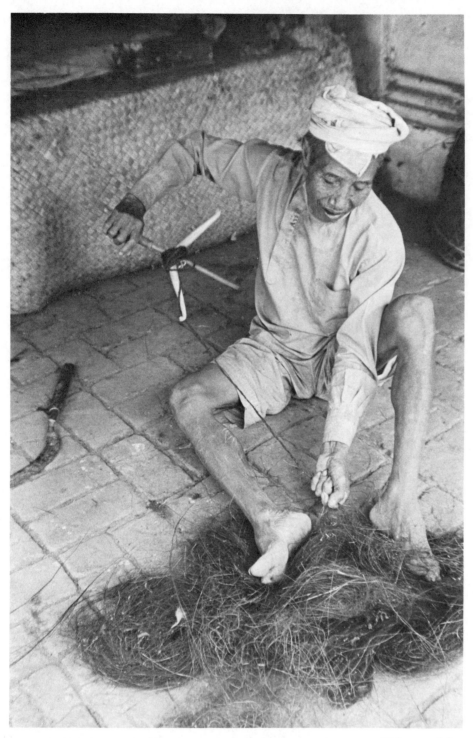

114b. With a hand whorl palm fibers are spun into a line that will be used for lashing the bamboo.

114c. Agile workmen tie the roof beams together. Although the craftsmanship is not particularly fine, the structure is sturdy because of the use of many ties and a well-braced design.

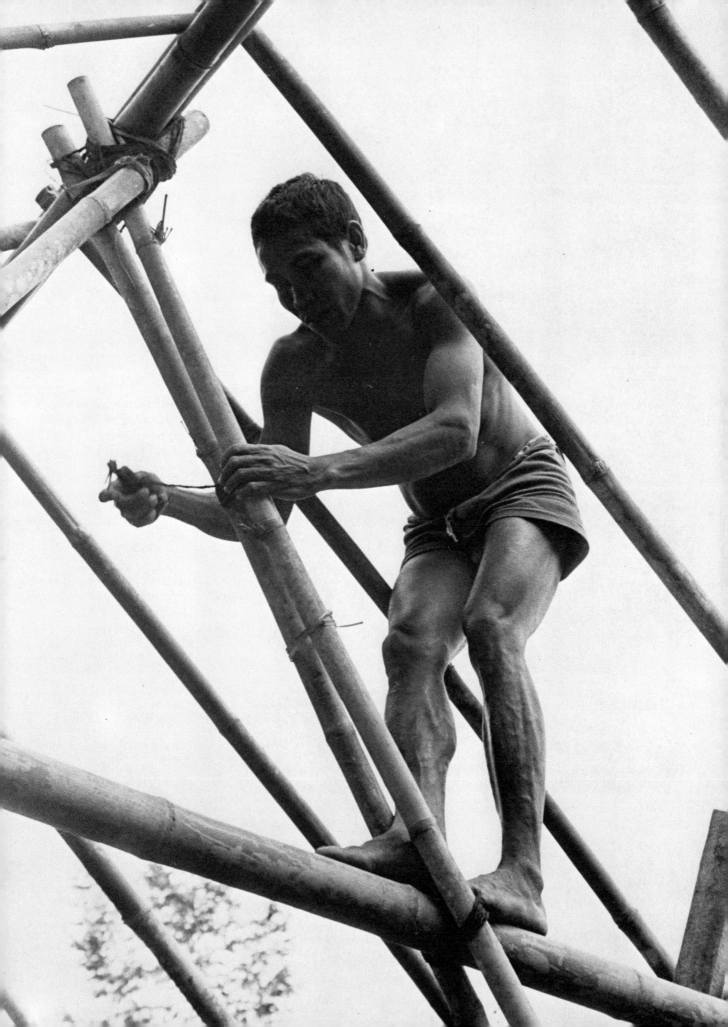

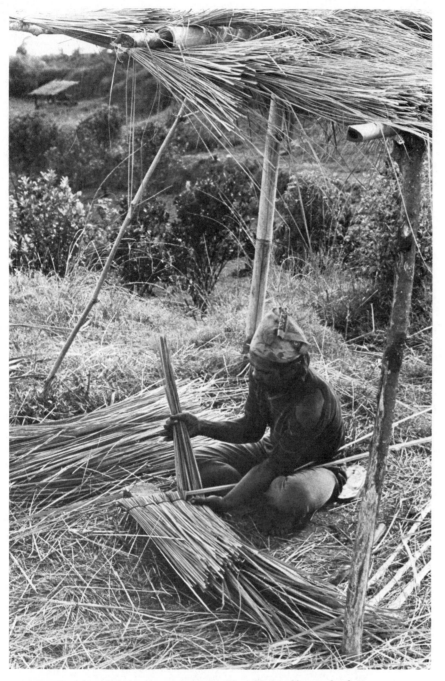

115. Thatching process, Shiraho, Ishigaki, Okinawa Prefecture, Japan. Individual bamboo poles are wrapped with the long grass that is stacked on the ground in front of the workman. Note the worker's palm hat, which is made of palm or bamboo leaves sewn over a frame. Photograph: Atsushi Kobayashi.

115a. Thatching process, Shiraho, Ishigaki, Okinawa Prefecture, Japan. Individual layers of thatch are placed on the rafters and sewn in place with a large bamboo needle and a thread made of miscanthus. Photograph: Atsushi Kobayashi.

114d. The thatch is made separately. Handfuls of long elephant grass are slid between two bamboo poles and fastened with palm-fiber rope. When a pole is finished, it is trimmed evenly at the bottom and attached to the roof.

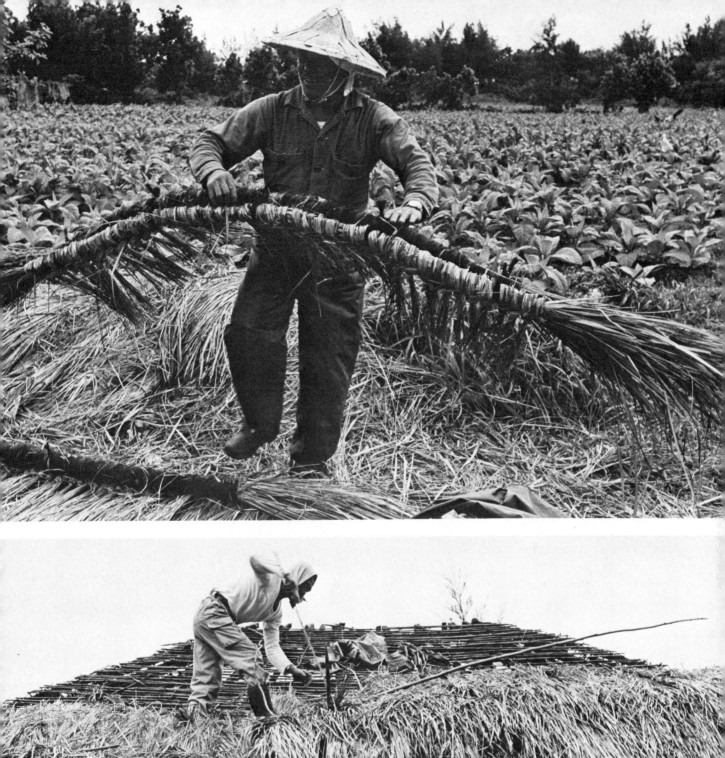
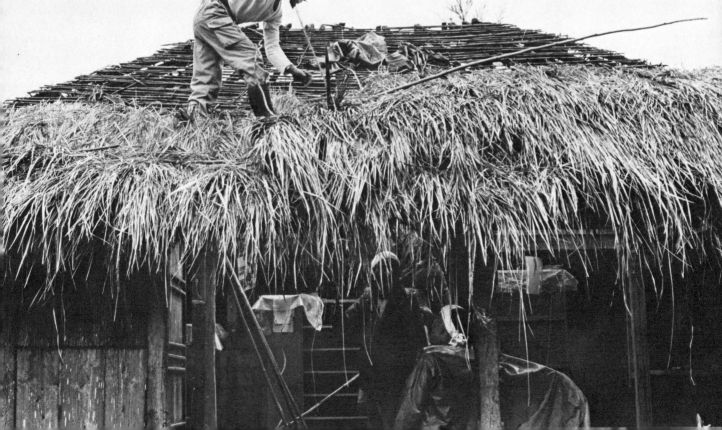

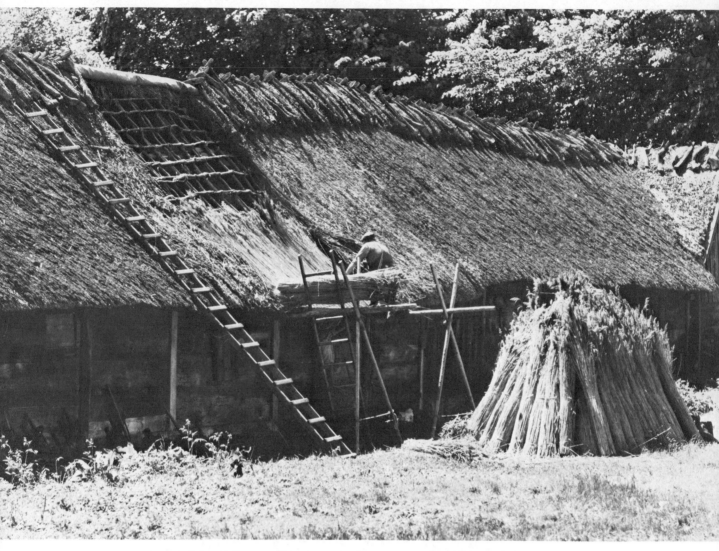

116. Thatching a roof, Frilandsmuseet, Jutland, Denmark. Thatching is now rare in Europe—this building is part of a historical architecture museum. The long straw bundles are stacked nearby on the ground. The thatcher lays approximately four inches of straw on the rafters and secures it tightly with twine. As one layer of straw overlaps the next, the thatch reaches a thickness of ten to twelve inches. As the thatch is layered, it is gently beaten with a flat wooden mallet to consolidate it into a firm mass. The bundles of straw are layered and tied longitudinally along the top of the roof. This provides a sturdy foundation for the wooden crown. Photograph: Mark Treib.

117. Thatched roof (inside view), Champuan, Bali, Indonesia. Traditional Balinese roof construction consists of bamboo rafters radiating from the center top. Split bamboo crossbeams support the rafters. The roof is covered with thatch made of elephant grass.

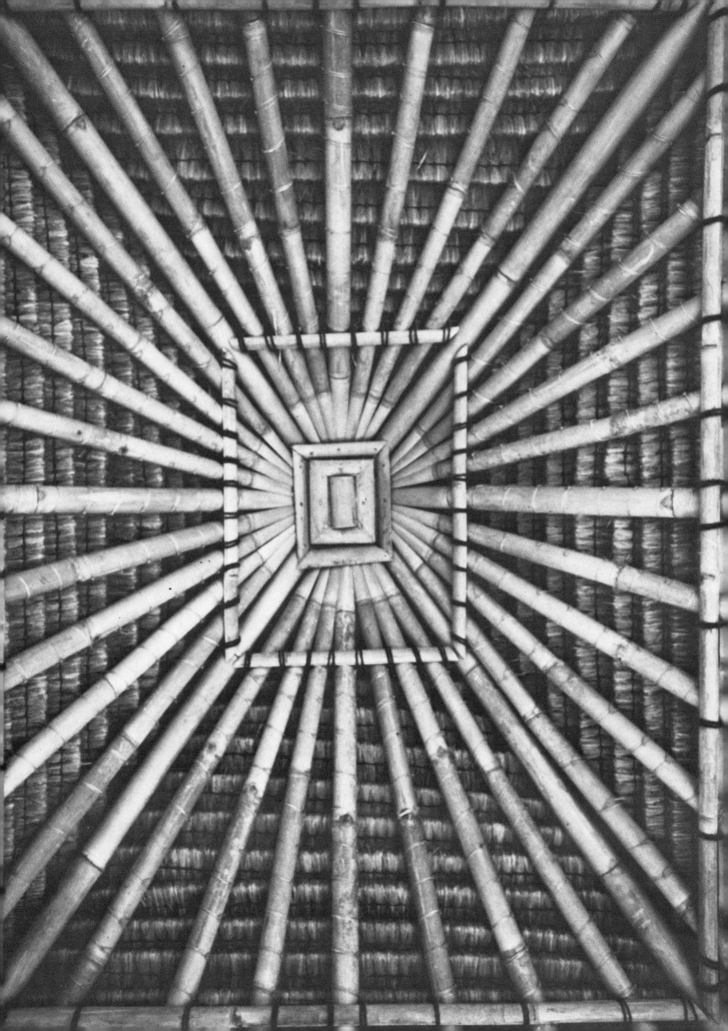

117a. Thatched roof (detail of inside), Champuan, Bali, Indonesia. The quality of thatch depends on how many individual thatch battens are overlaid. Here, the quality is excellent as the thickness of the thatch is approximately ten inches.

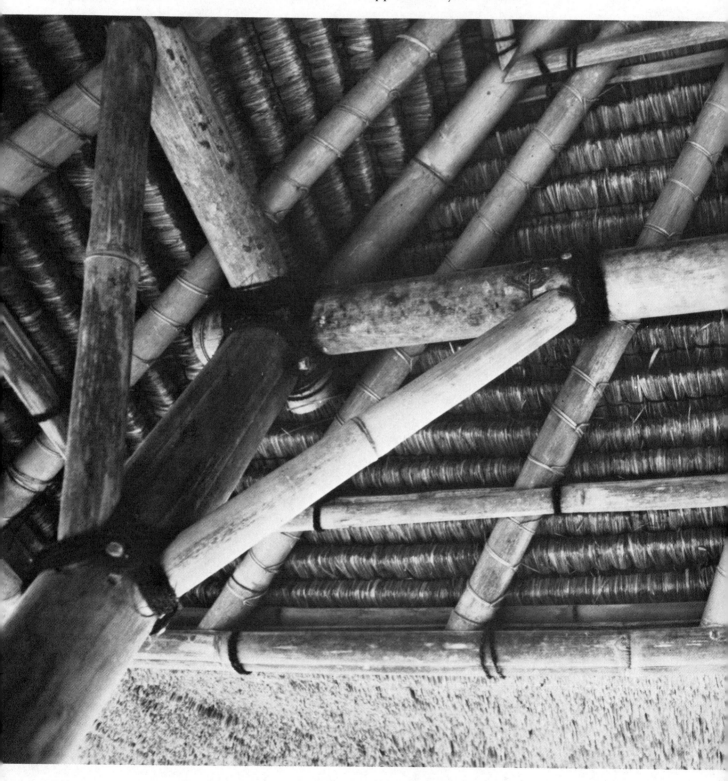

118. Bamboo shingle roof (detail), Kintamani, Bali, Indonesia. A unique type of bamboo shingle is made in the moist, cloud-covered mountains of Bali. The bamboo is split in half and a tab is cut into the upper portion, which then slides and locks over the rafters.

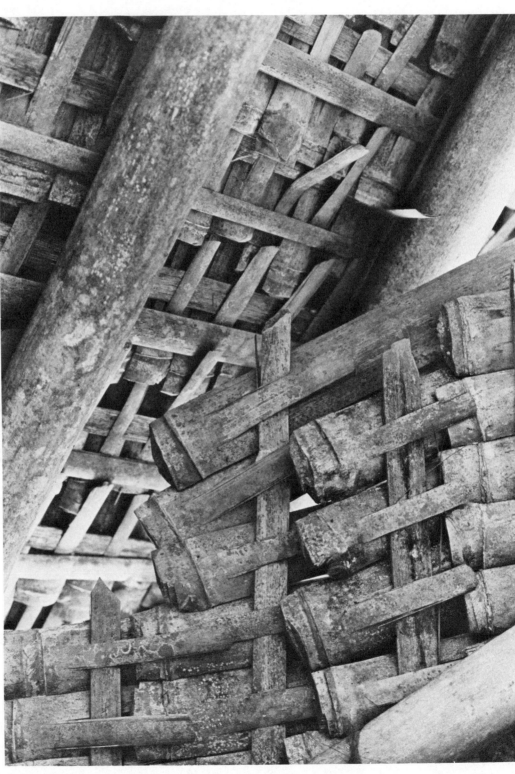

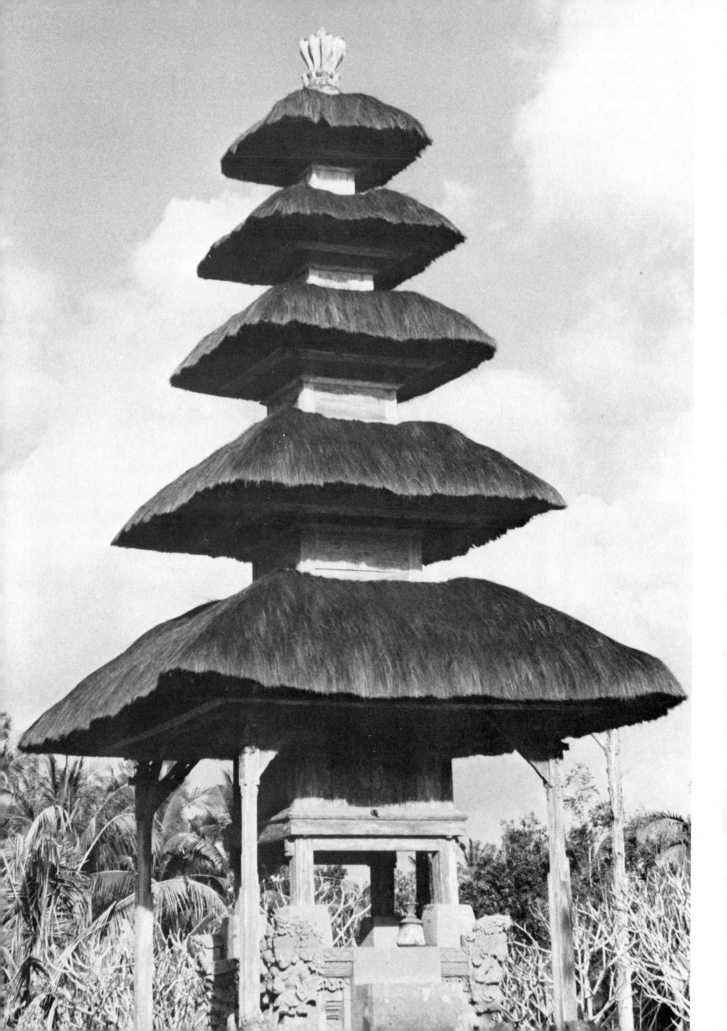

119. Mengwi Temple, Bali, Indonesia. Part of every Balinese temple is the *meru*, a structure of wood and stone with an odd number (between three and eleven) of stacked roofs. The thatched roofs are made of thick layers of sugar-palm fiber. An open shaft allows the gods to descend into the *meru*.

120. *Rondavel* house, Shorobe Settlement, Ngamiland, Botswana. Men and women join forces to construct a *rondavel* house. Men build the frame and women harvest and work the reeds. The inner wall of the *rondavel* looks like a continuous mat, but it is actually made of individual bundles of reed that have been laced directly to the crossbars of the house frame. Bundles of grass, now stored, will be attached to the roof. Photograph: Michael Yoffe.

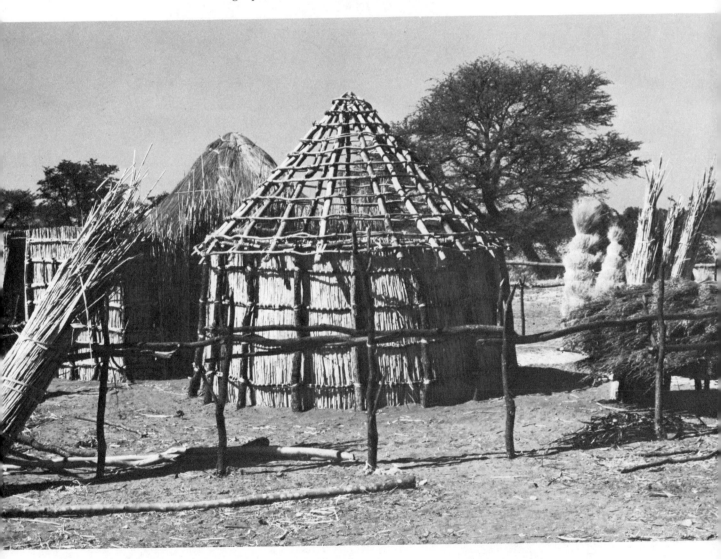

121. Reconstruction of a storehouse of the Yayoi period (c. 250 B.C.–A.D. 250), Toro village, Shizuoka Prefecture, Japan. In Japan the storehouse has evolved from a granary to a family treasure house. This roof is considerably thicker than most, with a supplementary roof which sits on top like a saddle. Photograph: Mark Treib.

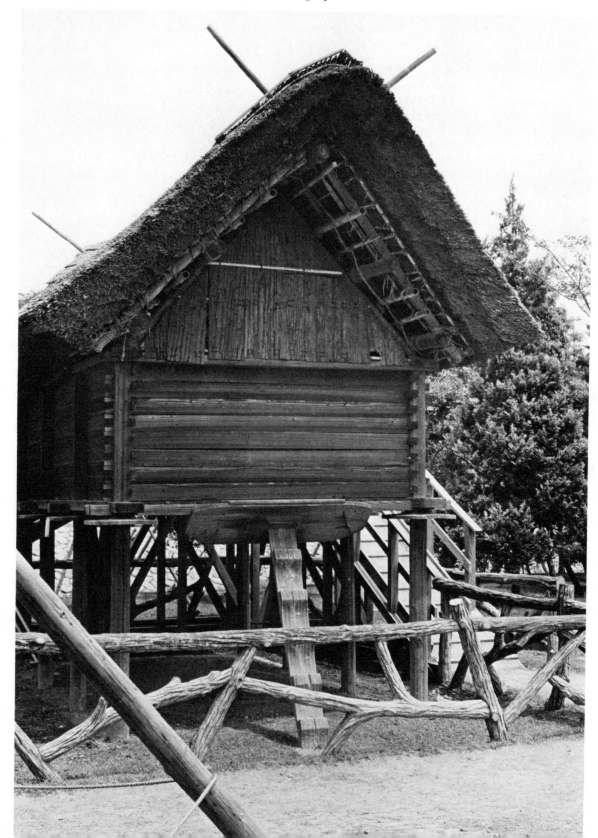

121a. Roof of the storehouse (detail). The thatch of this roof is made of a sedge or reed called *yoshi*. The thatch is lashed to bamboo rafters and bound to the roof with bamboo poles. As it is in Europe, the thatch is pounded with a wooden mallet and trimmed evenly around the eaves. Photograph: Mark Treib.

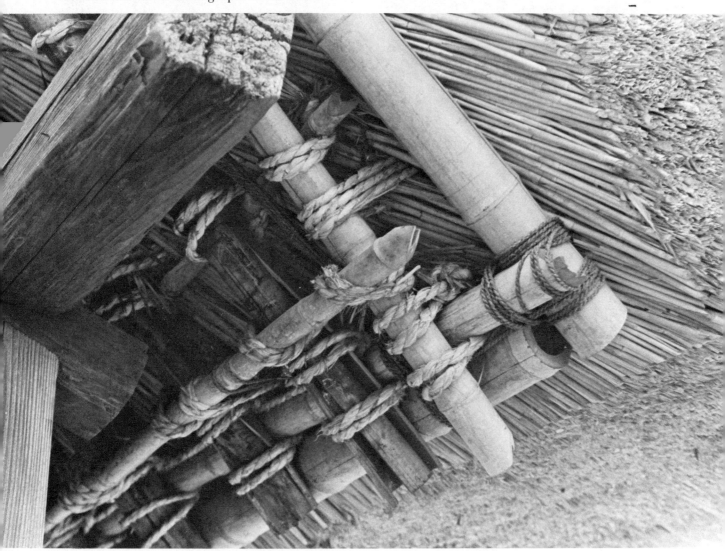

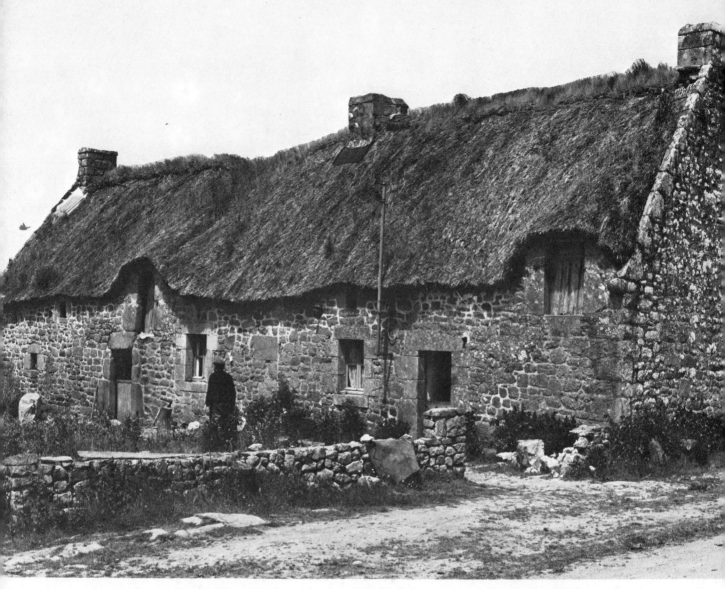

122. Stone house with thatched roof, Brittany, France. This thatched roof has a steep pitch and broad eaves, two features that help prevent water seepage. Photograph: Mark Treib.

123. Thatched roof of crofter's house, Shetland islands, Great Britain. A thick thatched roof is kept in place with a rope grid weighted by stones. Photograph: Mark Treib.

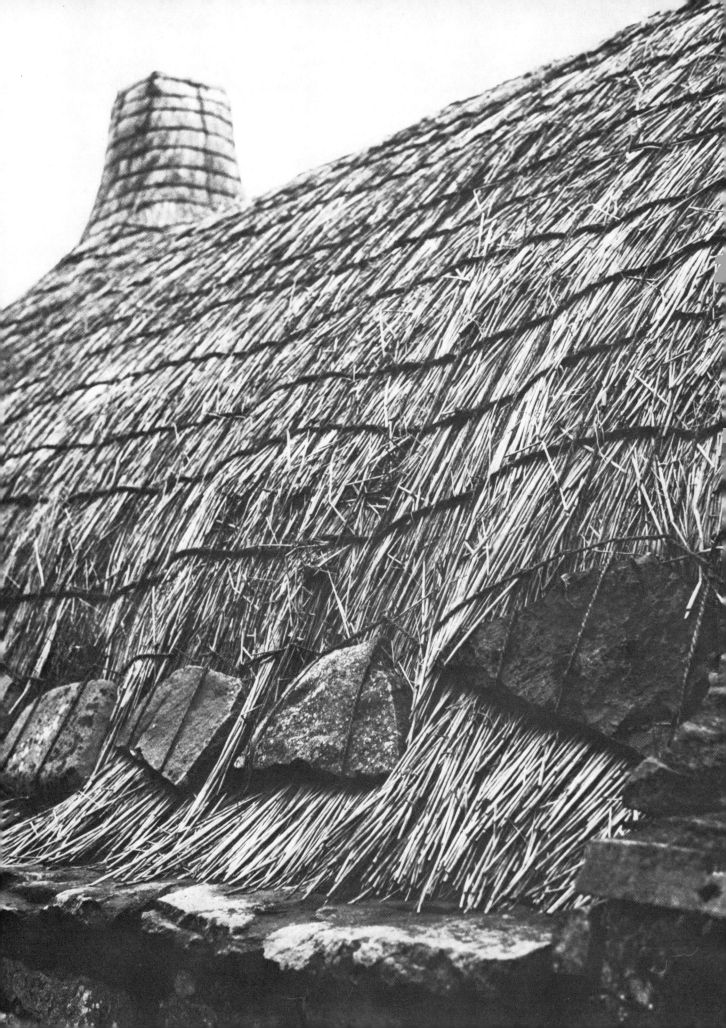

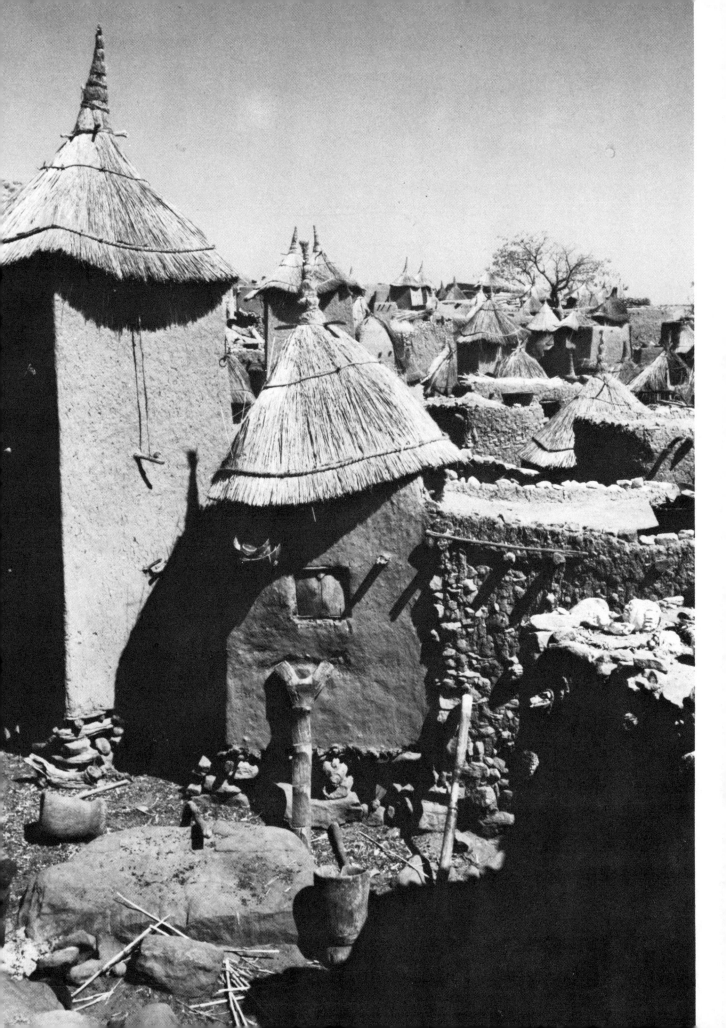

124. Thatched roofs, Dogon people, Mali. Both the mud walls and the grass thatch are the same gray color. In this area of Africa roofs are made separately and set on top of the mud structures. Photograph: Peter Nelson.

125. Zulu grass hut, Ngutu District, Kwazulu, South Africa. The Zulu hut is made from a variety of reeds and grasses. First, a framework of wattle laths is built by the men. Then the women weave mats from grasses that have been collected and dried during the preceding seasons. The mats for the sides and the ceiling are straight, but a circular mat is woven for the roof and a knob is made for the top. After all of the mats have been laid over and fastened to the structure, a roof net is attached to hold the roof in place. Built on a stony hillside, the hut becomes a natural part of the landscape. Photograph: Joan Bacharach.

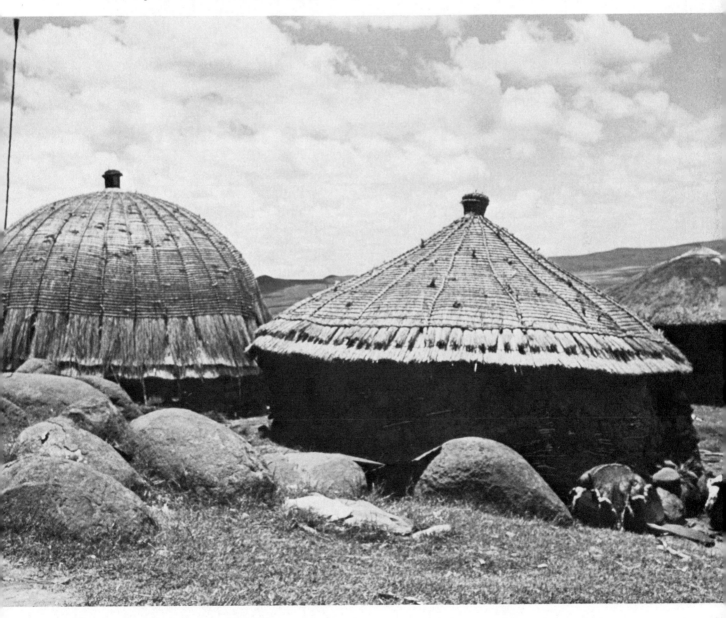

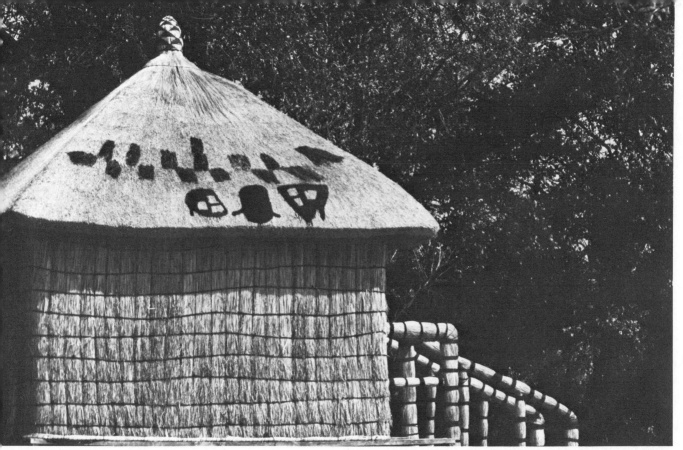

126. Straw house, Zambia. Three types of construction are used in this house: a layered thatch for the roof, a sewn binding technique for the walls, and a simple wrapped binding on the banister. Photograph: Michael Yoffe.

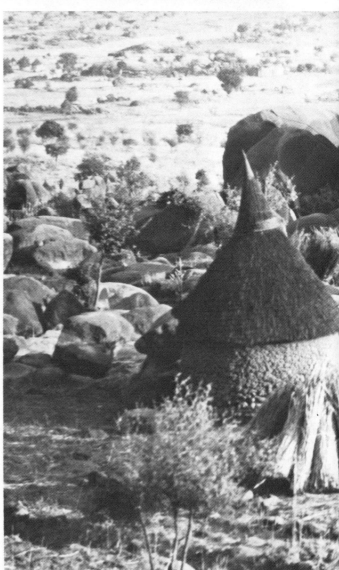

127. Mokolo village, northern Cameroon. These small mud buildings with pointed roofs blend into the surrounding rocky landscape. Bundles of freshly cut grass are stacked in several places. Photograph: Peter Nelson.

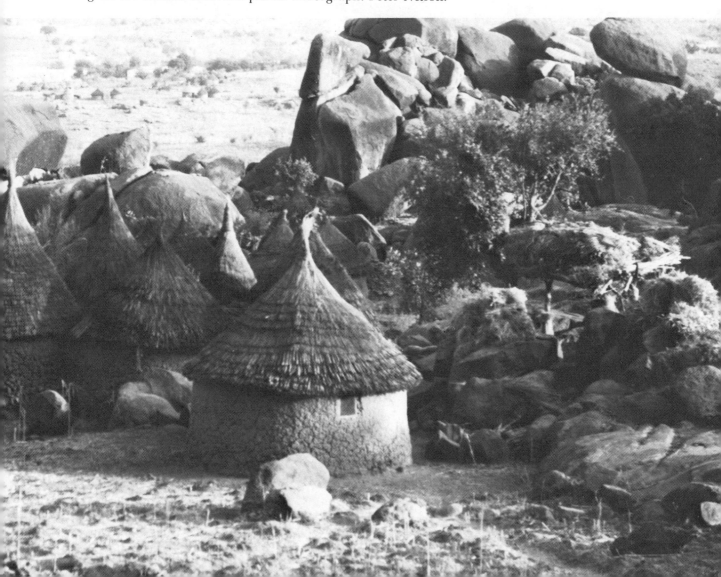

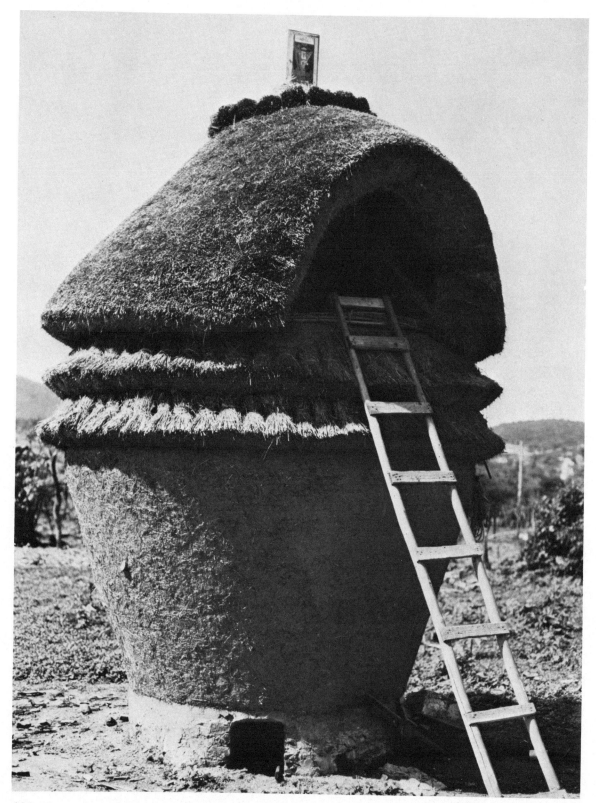

128. Corn granary, Oaxaca, Mexico. A stone base supports an earthenware urn, which is tapered to prevent rodents from climbing up the side. Two tiers of straw fringe belt the upper rim, and the graceful hood of the thatched roof protects the corn from sun and rain. A funnel at the top provides ventilation. Photograph: James Bassler.

129. Rice storage, Bali, Indonesia. Grass and palm silos store the year's rice crop at a safe distance from the animals. Their verticality provides a contrast to the basically horizontal housing compound. Photograph: Mary Hunt Kahlenberg.

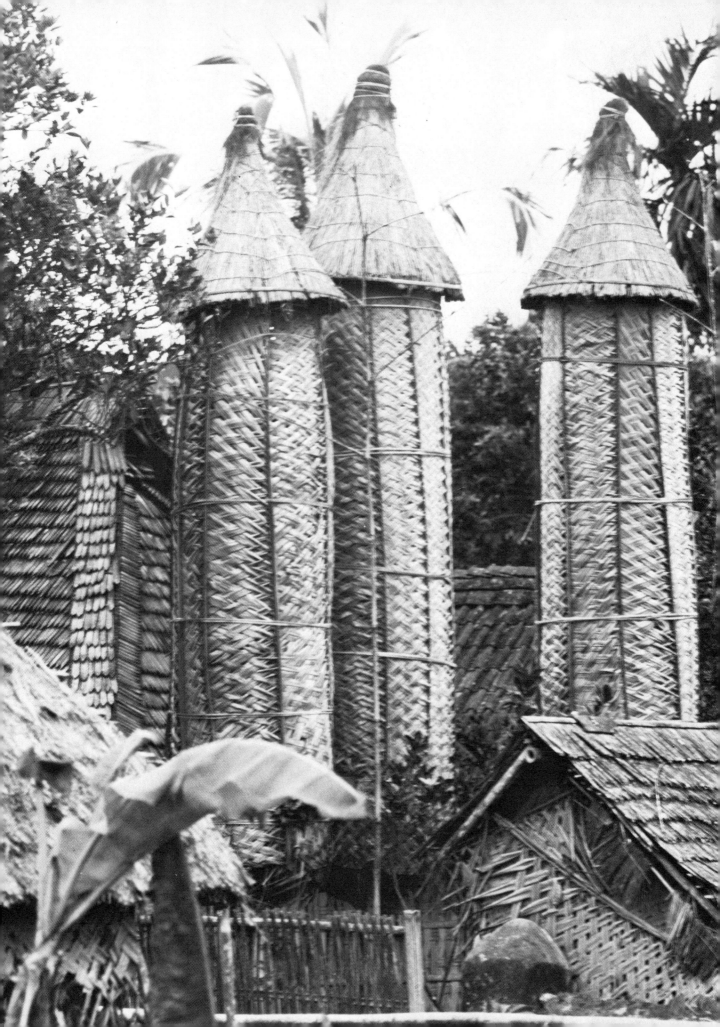

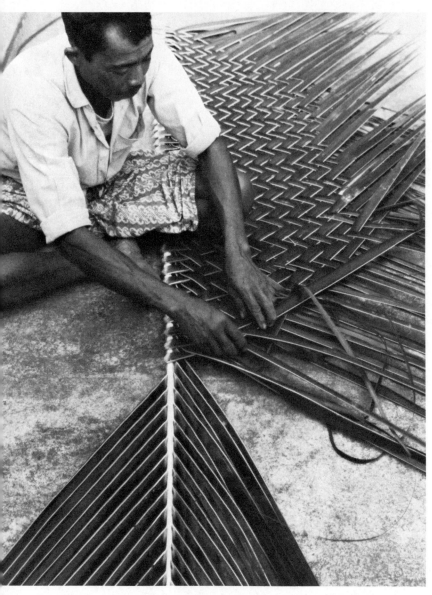

130. Weaving a palm wall or fence, Bali, Indonesia. A fence, wall, or roof may be made in a few minutes from a branch of the lontar palm. The long leaves on either side are simply plaited together.

131. Palm-leaf wall, Ubud, Bali, Indonesia. The wall around this Balinese family compound was made by plaiting the leaves of individual palm branches. The open weave allows air to pass through while providing sufficient privacy. Two altars are adorned with *lamaks* (palm offerings).

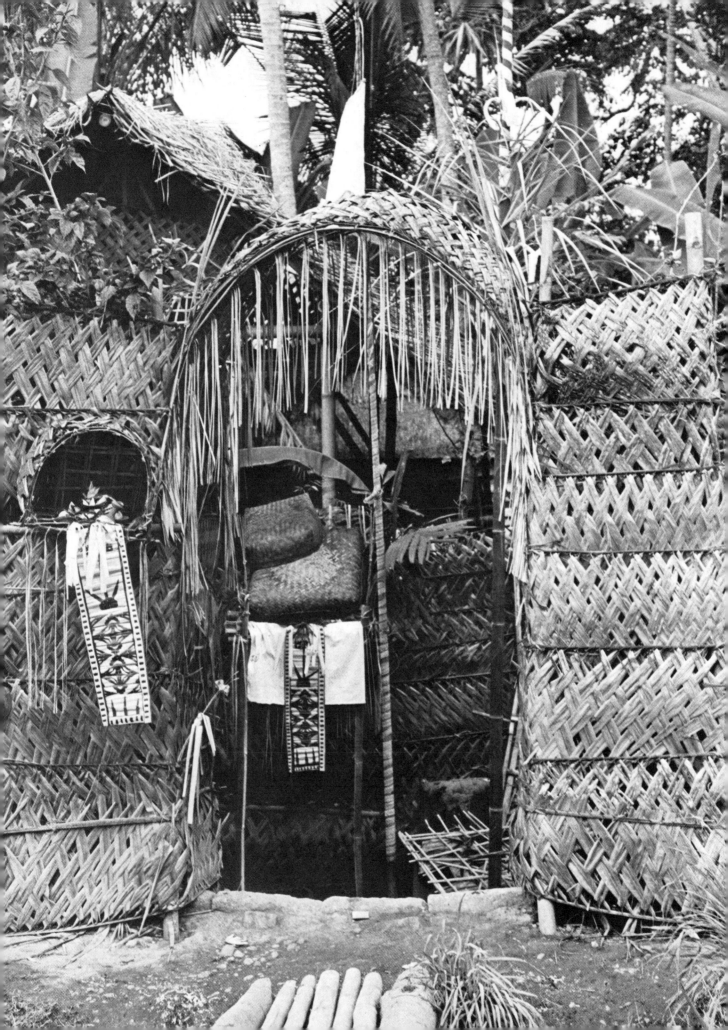

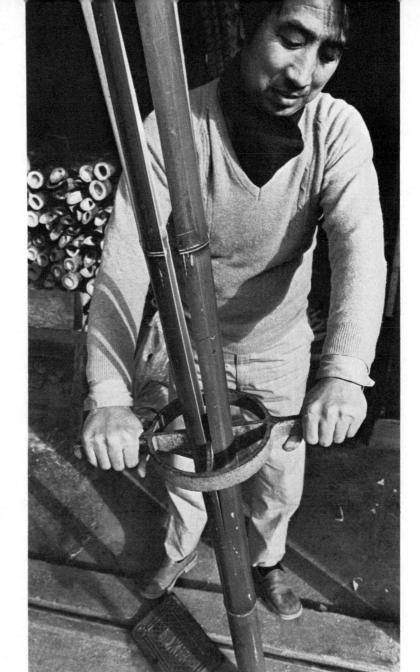

132. Splitting bamboo, Kyoto, Japan. This simple tool is used to split bamboo into quarters. As it has no annual rings like wood, bamboo can be easily split along its straight-grained length.

133. Sleeve fence (detail), Kyoto, Japan. Japanese fences utilize a variety of bamboo-splitting techniques. Here, a wide (4″ to 5″)-diameter piece of bamboo is split lengthwise into quarter-inch strips. These pieces are then bundled around a core of grass and shifted lengthwise so that the nodes are staggered. The flexibility created by this technique lets the fence-maker create subtle curves in the fence.

134. Sleeve fence (detail), Kyoto, Japan. Fences of this type are highly valued because of the immense amount of time needed to line up the small bamboo branches that create the undulating form. This visual motion of the branches is contrasted with wide sturdy posts and crossbars.

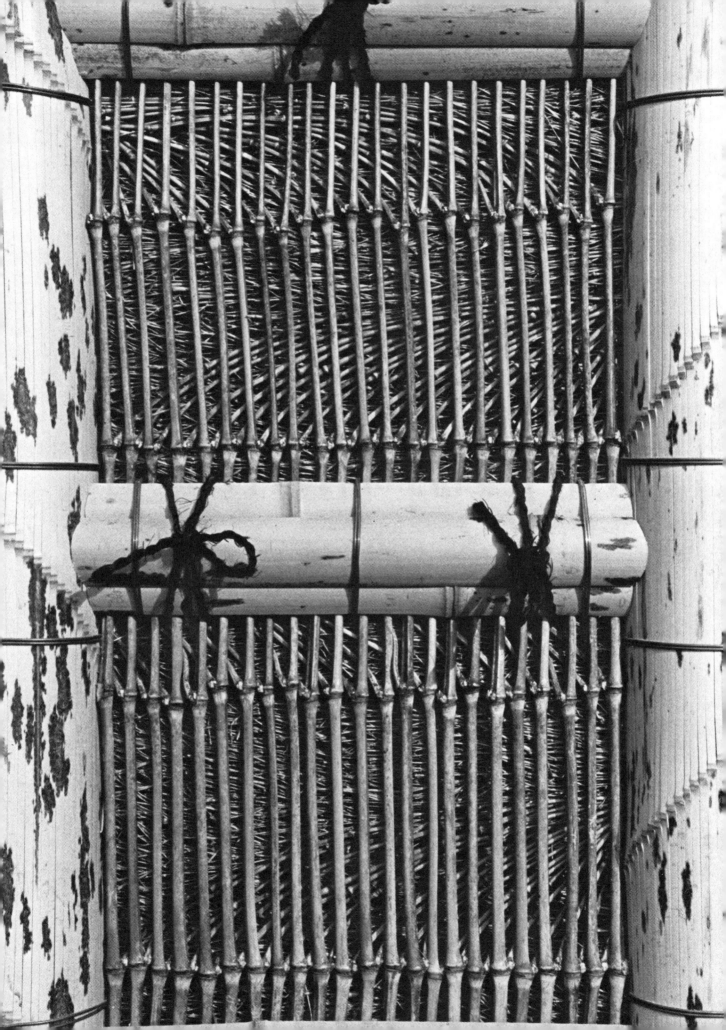

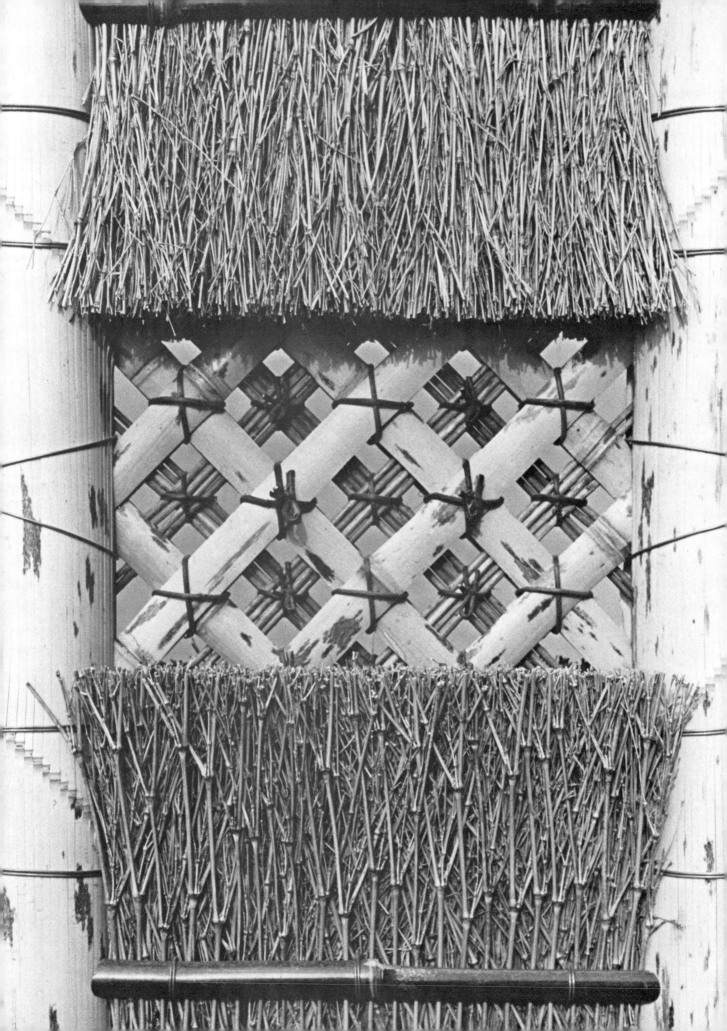

135. Sleeve fence (detail), Kyoto, Japan. One of the many variations of the garden fence, this one has split-bamboo sides. The diagonal grid of split bamboo is tied with wisteria vine and the "fringe" is made of many small, carefully aligned bamboo branches. The bamboo branches give a sense of natural growth. The open grid provides a window at eye level for a view into the garden.

136. Garden fence, Kyoto, Japan. This is a variation on the split-bamboo fence. Here the split is used for textural beauty rather than flexibility. The fence is made of two alternating rows of split poles that are lashed together with a horizontal pole at regular intervals. The fence is a visual barrier from the front, but allows one to see into the garden from the side.

107

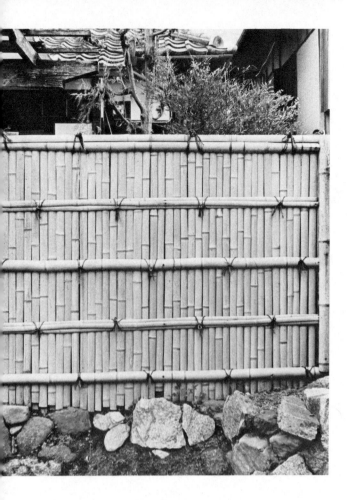

137. Bamboo fence, Kyoto, Japan. The Japanese use fences as both decorative and functional elements in their landscaping. This is one of the simplest fences. Halved lengths of bamboo are lined up and nailed to a board. A horizontal outer bamboo section is tied over the board and serves as a purely decorative element.

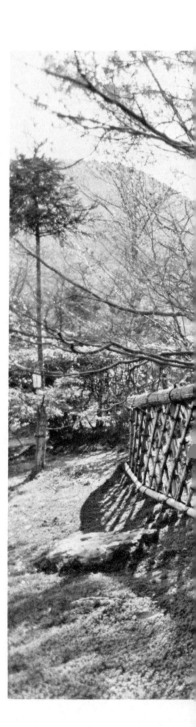

139. A garden fence (detail), Kiyomizu Temple garden, Kyoto, Japan. This simple fence is made of bamboo poles joined and tied with palm rope. Simple and beautiful, the fence blends into the landscape.

138. Japanese garden fence, Jojuin Garden, Kiyomizu Temple, Kyoto, Japan. There are two kinds of fences used in a Japanese garden: those intended to serve as partitions and those that serve as screens. This partition beautifully defines an area without completely blocking the view beyond it. It is constructed of split bamboo that is woven over a frame of fresh green bamboo and tied with black palm fiber. The light and dark tones combined with the luster of the bamboo lend elegance to this simple form.

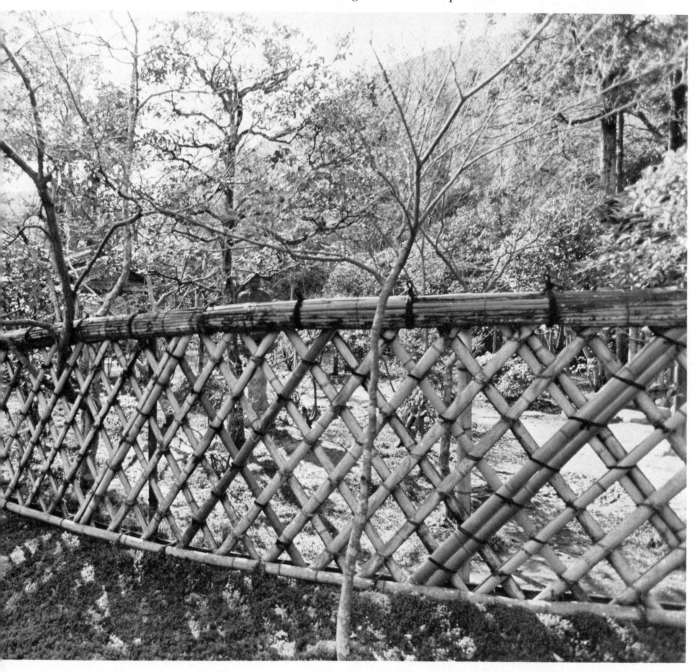

140. Window, Kyoto, Japan. 26¼″ x 27″. A clay-wall window, *shitaji-mado* in Japanese, literally translates as "under the earth window." Built into the clay wall of a teahouse, it is made of small lengths of bamboo and young bamboo branches. The famous tea master Senno-kikyo (1518–1591) is credited with having developed this style of window after having observed a farm hut where parts of the wall were missing, revealing the bamboo skeleton.

141. Rain gutter, tea house, Kyoto, Japan. This rain gutter takes full advantage of the tubular form of bamboo.

Bibliography

AUSTIN, ROBERT, and UEDA, KOICHINO. *Bamboo.* New York and Tokyo: Walker/Weatherhill, 1970.

BARLEY, MAURICE WILLMORE. *The English Farmhouse and Cottage.* London: Routledge & Kegan Paul, 1961.

BAUER, HELEN, and CARLQUIST, SHERWIN. *Japanese Festivals.* Garden City, N.Y.: Doubleday & Co., 1965.

BEETLE, ALAN A. "Sedge Boats in the Andes." *Journal of the New York Botanical Garden,* 46, no. 541 (January 1945).

BENET, SULA. *Song, Dance and Customs of Peasant Poland.* New York: Roy Publishers, 1951.

BINDER, PEARL. *Magic Symbols of the World.* London: Hamlyn, 1972.

BOBART, H. H. *Basketwork Through the Ages.* London: Oxford University Press, 1936.

BORGLUND, ERLAND. *Halm och Säv Modeller.* Västerås, Ica-Förlaget, 1966.

BOYD, E. *Popular Arts of Colonial New Mexico.* Santa Fe, N.M.: Museum of International Folk Art, 1959.

———. *Popular Arts of Spanish New Mexico.* Santa Fe, N.M.: Museum of New Mexico Press, 1974.

BRIGHAM, WILLIAM T. *Mat and Basket Weaving of the Ancient Hawaiians.* Memoirs of the Bernice Pauaki Bishop Museum, 2, no. 1. Honolulu: Bishop Museum Press, 1906.

BROWN, VINSON, and ANDREWS, DOUGLAS. *The Pomo Indians of California and Their Neighbors.* Healdsburg, Calif.: Naturegraph Publishers, 1969.

BRUNSKILL, R. W. *Illustrated Handbook of Vernacular Architecture.* London: Faber & Faber, 1970.

BURKILL, I. H. *A Dictionary of the Economic Products of the Malay Peninsula.* Oxford: Oxford University Press, 1935.

CASTILE, RAND. *The Way of Tea.* New York: Weatherhill, 1971.

CHASE, JUDITH WRAGG. *Afro-American Art and Craft.* New York: Van Nostrand Reinhold, 1971.

COKER, ALEC. *The Craft of Straw Decoration.* Wood-Ridge, N.J.: The Dryad Press, 1971.

COOPER, MERIAN C. *Grass.* New York: G.P. Putnam's Sons, 1925.

CULIN, STEWART. *Games of the Orient.* Reprint. Rutland, Vt.: Charles E. Tuttle Co., 1958. (Originally published in 1895 by University of Pennsylvania, Philadelphia.)

DAVEY, NORMAN. *A History of Building Materials.* London: Phoenix House, 1961.

DE LIMA, FERNANDO DE CASTRO PIRES. *A'Arte Popular em Portugal, ilhas adjácentes e ultramar Verbo* (no date).

DYER, JAMES, STYGALL, FRANK, and DONY, JOHN. *The Story of Luton.* Luton, Eng.: White Crescent Press, 1964.

ENGEL, HEINRICH. *The Japanese House: A Tradition for Contemporary Architecture.* Rutland, Vt., and Tokyo: Charles E. Tuttle Co., 1964.

EVANS, E. ESTYN. *Irish Folkways.* London: Routledge & Kegan Paul, 1957.

FOLEY, DANIEL J. *Christmas the World Over.* New York: Chilton Books, 1963.

FORBES, R. J. *Studies in Ancient Technology.* vol. 3. Leiden, Neth.: E. J. Brill, 1955.

FORCE, ROLAND W., and FORCE, MARYANNE. *The Fuller Collections of Pacific Artifacts.* London: Lund Humphries, 1971.

FRAZER, JAMES GEORGE. *The Golden Bough—A Study in Magic and Religion.* vol. 1, abr. ed. New York: The Macmillan Company, 1940.

———. *The Golden Bough, Part V, Spirits of the Corn and of the Wild.* vols. 1 & 2, 3rd ed. London: Macmillan and Company, 1925.

FREEMAN, CHARLES. *Luton and the Hat Industry.* The Corporation of Luton Museum and Art Gallery. Luton: White Crescent Press, 1964.

GARDI, RENE. *Indigenous African Architecture.* New York: Van Nostrand Reinhold, 1973.

GINK, KÁROLY, and KESS, IVAN SÁNDOR. *Folk Art and Folk Artists in Hungary.* Budapest: Corvina Press, Kossuth Printing House, 1968.

GRAVES, RICHARD. *Bushcraft, a Serious Guide to Survival and Camping.* New York: Schocken Books, 1972.

GRIGSON, GEOFFREY. *An English Farmhouse and Its Neighbourhood.* London: Max Parrish and Company, 1948.

HARVEY, MARIAN. *Crafts of Mexico.* New York: The Macmillan Company, 1973.

HAYAKAWA, MASAO. *The Garden Art of Japan.* New York: Weatherhill, 1973.

HIBBS, RUTH S. *Straw Sculpture Techniques and Projects.* New York: Drake Publishers, 1974.

HIDEO, HAGA. *Japanese Folk Festivals Illustrated.* Tokyo: Miura Printing Co., 1970.

HODGES, HENRY. *Artifacts: An Introduction to Early Materials and Technology.* London: John Baker, 1964.

JACKOWSKI, ALEKSANDER, and JARNUSZKIEWIEZ, J. *Folk Art of Poland.* Warsaw: Arkady, 1968.

JAMES, GEORGE WHARTON. *Practical Basket Making.* Pasadena, Calif.: G. W. James, 1936.

KAHN, LLOYD, ed. *Shelter.* Bolinas, Calif.: Shelter Publications, 1973.

KNUFFEL, WERNER E. *The Construction of the Bantu Grass Hut.* Graz, Austria: Akademische Druck u. Verlagsanstalt, 1973.

LAMBETH, M. *Discovering Corn Dollies.* Aylesbury, U.K.: Shire Publications, 1974.

————. *A New Golden Dolly.* Cambridgeshire: The Cornucopia Press, 1966.

LUCAS, A. *Ancient Egyptian Materials and Industries.* 2d ed., rev. London: Edward Arnold & Co., 1934.

MARCUSE, SIBYL. *A Survey of Musical Instruments.* New York: Harper & Row, 1975.

MASON, OTIS TUFTON. *Aboriginal American Basketry: Studies in a Textile Art Without Machinery.* Reprint. Glorieta, N.M.: The Rio Grande Press, 1970.

MAXWELL, GAVIN. *People of the Reeds.* New York: Harper Brothers Publishers, 1957. (Published in England under the title of *A Reed Shaken by the Wind.*)

MEAD, S. M. *Traditional Maori Clothing: A Study of Technological and Functional Change.* Sidney: A. H. & A. W. Reed, 1969.

MILES, CHARLES, and BOVIS, PIERRE. *American Indian and Eskimo Basketry.* New York: Bonanza Books, 1969.

MUNSTERBERG, HUGO. *The Folk Arts of Japan.* Rutland, Vt.: Charles E. Tuttle Co., 1958.

NICOLAISEN, JOHANNES. *Ecology and Culture of the Pastoral Tuareg.* Copenhagen: The National Museum, 1963.

OKA, HIDEYUKI. *How to Wrap Five Eggs.* New York: Harper & Row, 1967.

————. *How to Wrap Five More Eggs.* New York: Weatherhill, 1975.

OLIVER, PAUL. *Shelter in Africa.* London: Barrie & Jenkins, 1971; New York: Praeger Publishers, 1971.

PAZ, OCTAVIO. *In Praise of Hands—Contemporary Crafts of the World.* New York: New York Graphic Society, 1974.

RAMSEYER, URS. *The Art and Culture of Bali.* London: Oxford University Press, 1977.

ROSSBACH, ED. *Baskets as Textile Art.* New York: Van Nostrand Reinhold, 1973.

————. "The Mats of Nabeul." *Craft Horizons,* 31, no. 2 (April 1971).

SANFORD, LETTICE. *Straw Work and Corn Dollies.* New York: A Studio Book, The Viking Press, 1974.

SONOBE, SAKAMOTO, and POMEROY. *Japanese Toys—Playing with History.* Rutland, Vt.: Charles E. Tuttle, Co., 1965.

TANAKA, SEN ö. *The Tea Ceremony.* Tokyo: Kodansha International, 1973.

TELEKI, GLORIA ROTH. *The Baskets of Rural America.* New York: Dutton Paperbacks, 1975.

TE RANGI HIROA (Peter H. Buck). *Arts and Crafts of Hawaii.* Honolulu: Bishop Museum Press, 1957.

TOLLER, JANE. *Prisoners of War Work—1756–1815.* Cambridge: The Golden Head Press, 1965.

TROWELL, MARGARET, and WACHSMANN, K. P. *Tribal Crafts of Uganda.* New York: Oxford University Press, 1953.

WEISER-AALL, LILY. *Julehalmen I Norge.* Oslo: Utgitt av Norsk Folkemuseum, 1953.

WILLIAMS, CHRISTOPHER. *Craftsmen of Necessity.* New York: Vintage Books, 1974.

WULFF, HANS E. *The Traditional Crafts of Persia.* Cambridge: The M.I.T. Press, 1966.

Notes

1. HENRY YULE and A. C. BURNELL, *Hobson-Jobson* (1903; reprint ed., London, 1969), pp. 54–55.

2. JAMES J. FOX, *Harvest of the Palm* (Cambridge: Harvard University Press, 1977), pp. 143–144.

3. *Ibid.,* pp. 144–145.

4. HENRY HODGES, *Technology in the Ancient World* (London: Penguin, 1970), p. 33.